Watercolor

EXPRESSIONS

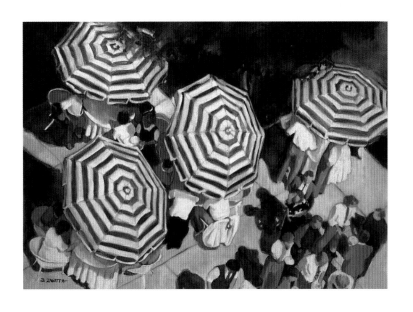

EXPRESSIONS

123 ARTISTS CREATE MOODS
WITH BRUSH AND PAINT

selected by Betty Lou Schlemm

GLOUCESTER MASSACHUSETTS

QUARRY PUBLISHERS

First published in the United States of America by:
Quarry Books, an imprint of
Rockport Publishers, Inc.
33 Commercial Street
Gloucester, Massachusetts 01930-5089
Telephone: (978) 282-9590
Fax: (978) 283-2742

Distributed to the book trade and
art trade in the United States by

North Light Books, an imprint of
F & W Publications
1507 Dana Avenue
Cincinnati, Ohio 45207
Telephone: (800) 289-0963

Other distribution by
Rockport Publishers, Inc.
Gloucester, Massachusetts 01930-5089

ISBN 1-56496-645-3

10 9 8 7 6 5 4 3 2 1

Graphic Design: Susan W. Gilday

Cover Image: *Garden Party,* by Donna Zagotta (see page 36)

Back Cover Images: Left: *Lanterns,* by Carol Weisenauer, (see page 97); Middle: *Garden Party,* by Donna Zagotta (see page 36); Right: *A Tricycle Forgotten II*, by D. Denghausen, (see page 23)

Half-Title Page Image: *Garden Party,* by Donna Zagotta (see page 36)

Page Five Images: (top left) *The Orange Belt IV*, by Gloria Paterson (see page 135), (top right) *Big Pink Flower*, by Elise Morenon (see page 132), (bottom) *September*, by Ann Kromer (see page 56)

Printed in China.

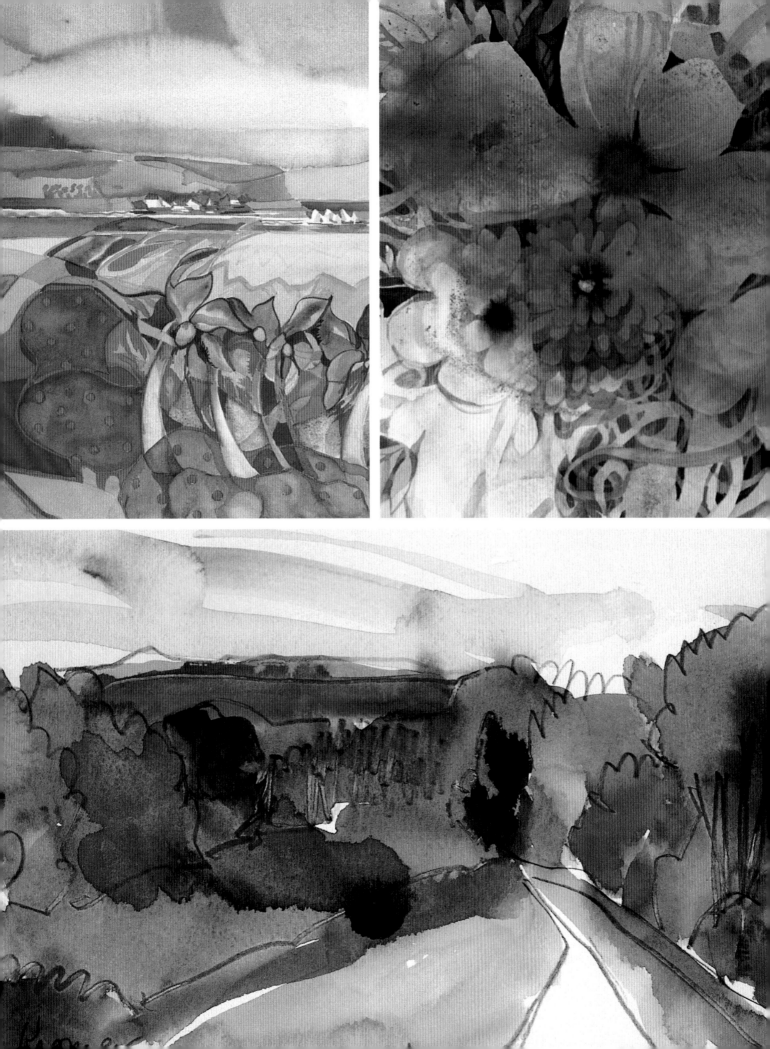

INTRODUCTION

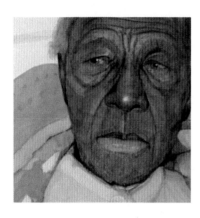
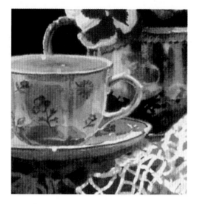

WHAT DOES IT MEAN TO CREATE EXPRESSIVE WATERCOLORS?

To imbue a thought, a word, a sign, or symbol with emotion—to use values and color, playing them off each other as a musician plays different chords of music, choosing them as carefully as poets choose their words.

To be amongst the gypsies and feel the warmth from their fires and to hear hammers pounding on anvils—this is Verdi's great "Anvil Chorus" from *Il Trovotore*. We sense the joy of a Chagall painting—imagine a cow jumping over the moon. The sensitive and careful mixing of color and values, those wonderful brushstrokes that place the colors side by side—this is a Monet painting telling us the exact time of day.

Through music and vision, we see Brünnhilde leaping on her horse, dashing forth into battle, with the Valkyries frantically moving all about. We are part of this battle; it is from Wagner's famous opera, *Die Walküre!* When we hear the delicate tones of the "Moonlight Sonata," a sense of peacefulness comes over us.

Tennyson's poem *Fragment* writes of a flower in the cranny of a wall. It is so simply written, yet it reveals the mysteries of life.

As we sit before our subject, we forget all else; we are one with our subject. All we have are colors, lines, and values. We add mediums, shapes, and forms in pictorial space to make a composition. We have color choices to make—how light, how dark, which ones to place next to each other. We're so careful about how they touch, the wonderful edges they make. We are in a different world, the world of painting—and all of us have our own world, and this is how we put it down. We call it expressive watercolor.

—Betty Lou Schlemm, A.W.S., D.F.

Below: Colleen Newport Stevens, *Midnight on the Ice,* 20" × 30" (51 cm × 76 cm), Lanaquarelle 300 lb., **(see page 25); Facing Page, Left:** Dean Mitchell, *Rowena's Last Visit,* 20" × 30" (51 cm × 76 cm), Crescent hot-press watercolor board, **(see page 28), Facing Page, Right:** Liz Donovan, *Pansies with Teacup,* 24.25" × 14" (61.5 cm × 36 cm), Arches 300 lb. cold press, **(see page 52)**

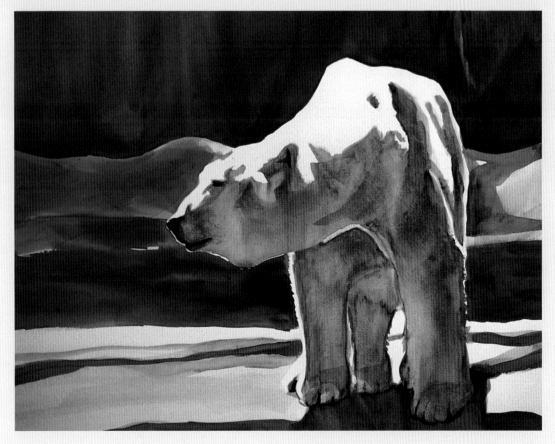

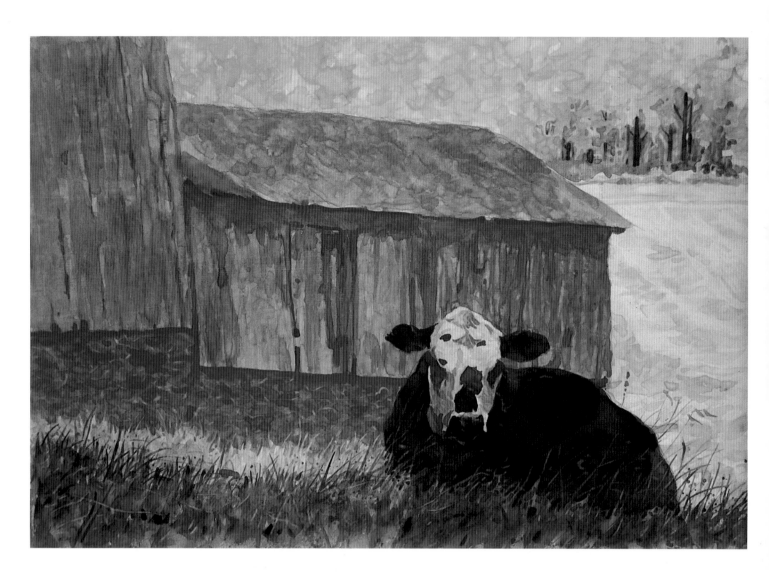

I observed this scene on a sunny day in Virginia. To express its joyousness, I exaggerated the color scheme, making everything appear even brighter than it was.

Bill James
Bolen's Barn with Cow

18" x 26" (46 cm x 66 cm)
Watercolor with transparent gouache

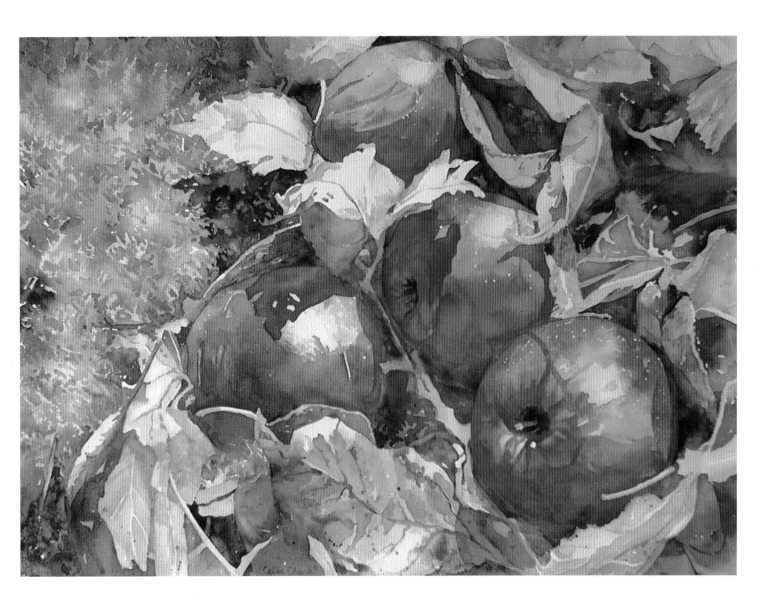

Fall is the most glorious time of year in the Northeast, and this painting expresses the warmth and sense of ease that this season brings. To achieve the exhilarating colors, I applied layers of transparent watercolor in thin glazes.

Celia Clark
Windfalls

24" x 30.5" (61 cm x 77 cm)
Arches 140 lb. cold press

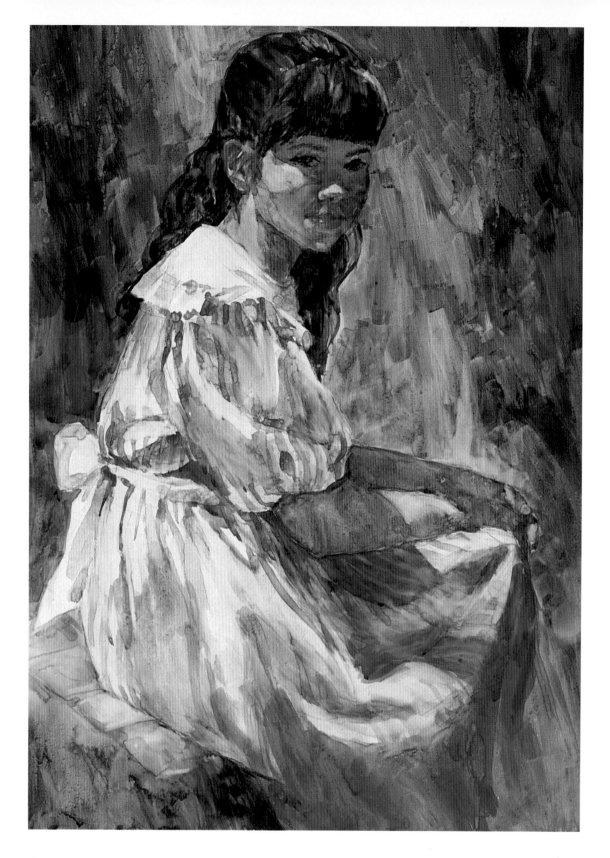

The emotions expressed in this painting are contentment, tranquility, and serenity.

Barbara George Cain
Katherine

30" x 22" (76 cm x 56 cm)
Arches gesso-coated 140 lb. hot press
Watercolor on gesso-coated paper

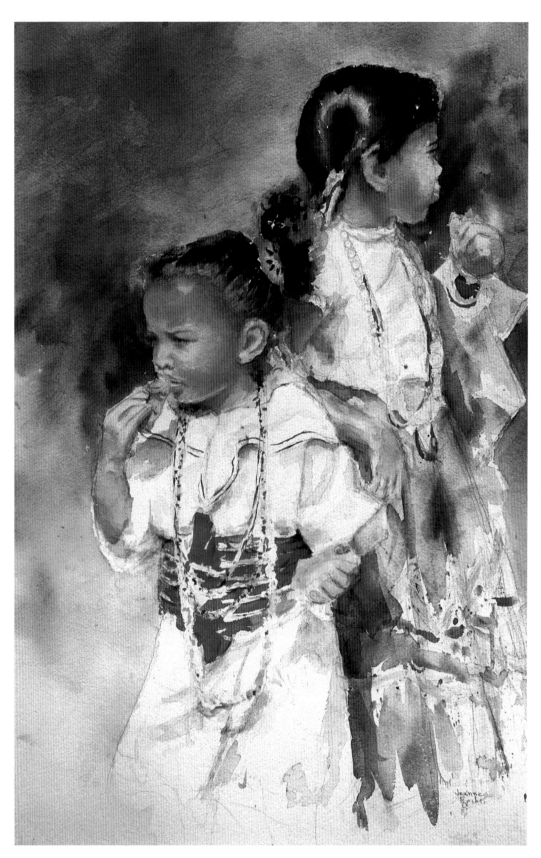

I used dark values behind the faces to bring out the expression of wonderment,
and added colorful accents to demonstrate the excitement of the festivities.

Jeanne A. Ruchti
Annie Whitehorse Celebration

30" x 22" (76 cm x 56 cm)
Arches 300 lb. rough

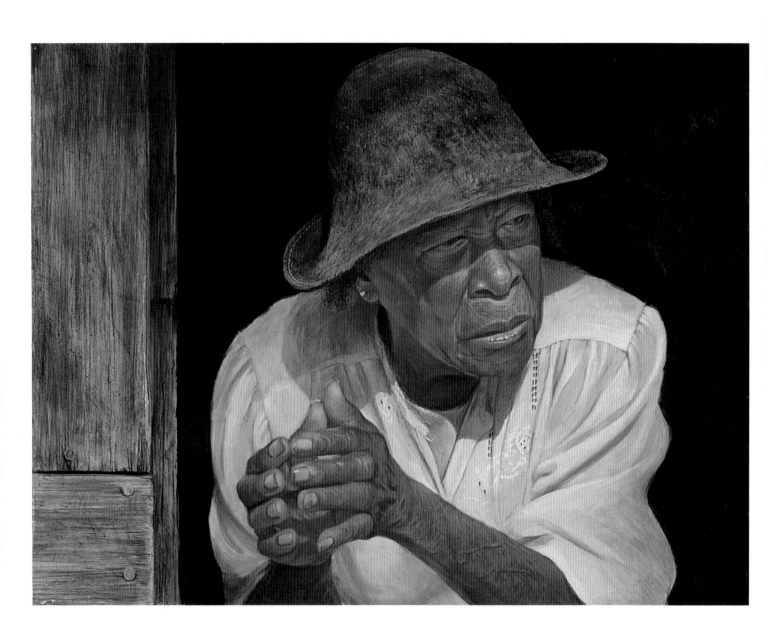

This small egg tempera is of a ninety-year-old friend of mine who loved to chat at her windowsill. As this is her favorite spot, my strong feelings for this woman led me to paint her there just as the morning sun began to heat up the day. Her comfortable stance reinforces her friendly reminiscences.

Jerry Rose
Felt Hat

12" x 16" (30 cm x 41 cm)
Gessoed panel
Watercolor with egg tempera

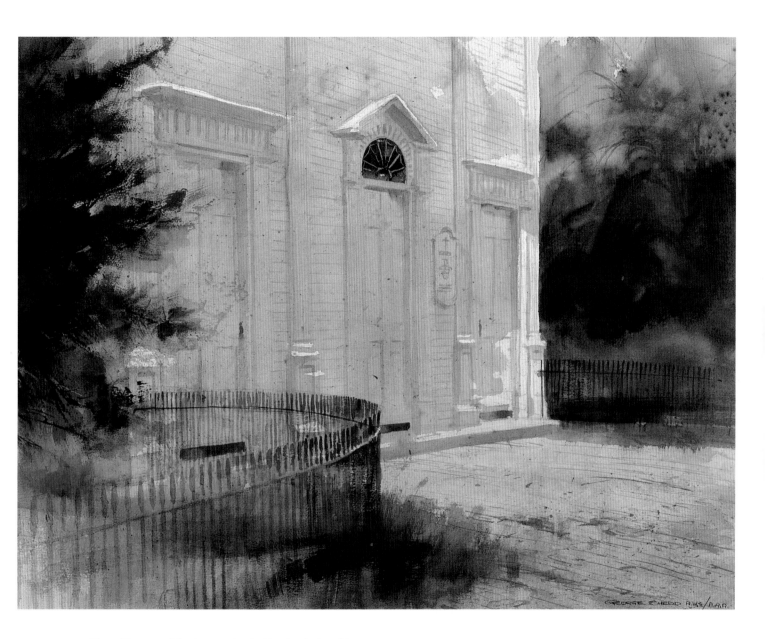

Three Doors to Salvation *was inspired by the dignity of these church doors and the hope and spiritual comfort that can be found within.*

George Shedd
Three Doors to Salvation

22" x 30" (56 cm x 76 cm)
Arches 300 lb. cold fresco

With nature as my inspiration, I paint as a form of creation, as a means of staying in contact with nature and sharpening my perception of it. Wind Dancer is an expression of freedom (conveyed with fine washes of light colors) and joy (evident in the dark areas that make the light dance).

Barbara Scullin
Wind Dancer

20" x 30" (51 cm x 76 cm)
Arches 300 lb.

The fog started rolling in on Monhegan Island. The foghorn made its eerie sound while the boats were being worked on. In my painting, the water carries random reflections of other places and other times. I added washes to the transparent watercolor to give it depth and enhance its somber mood. The warm reds, however, provide a little cheerful relief.

D. Gloria Devereaux
Winter Haul

15" × 22" (38 cm × 56 cm)
Arches 140 lb. cold press

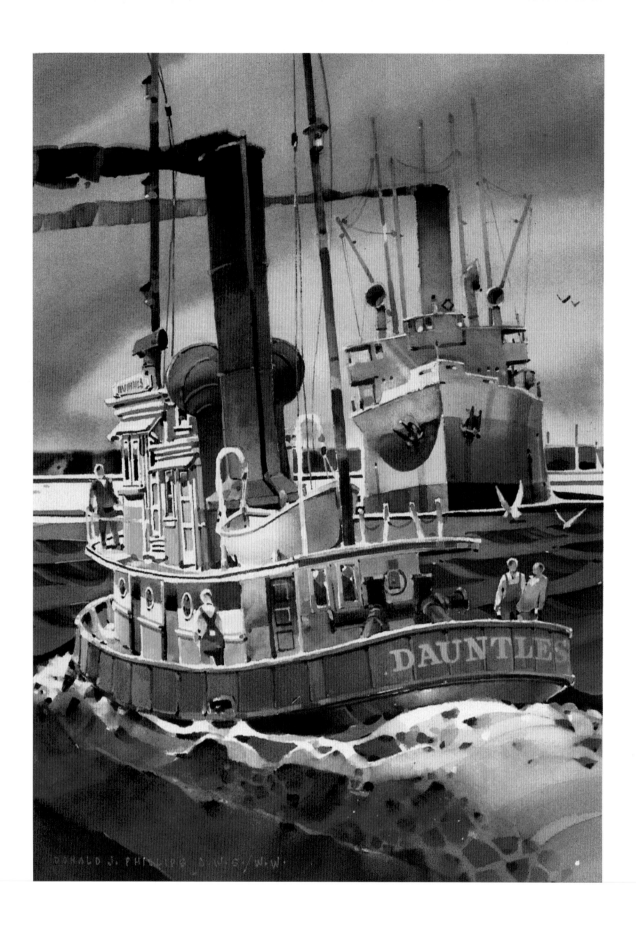

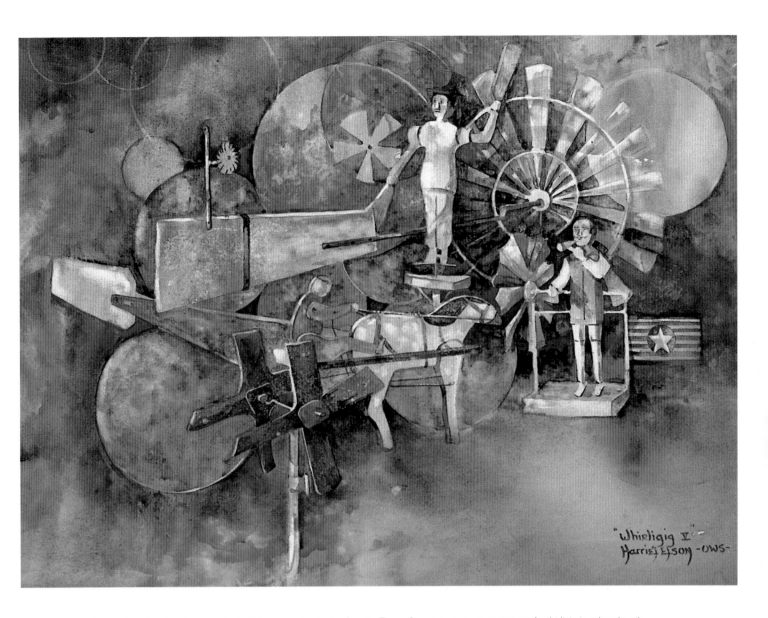

I have long loved antiques, and whirligigs are a particular favorite. They often appear in my paintings. A whirligig is a handmade toy that's meant to be kept outside. The whittler is not held back by rules of design, but is free to create his vision. A whirligig's only purpose is to show that the wind is blowing and to put a smile on the face of the viewer.

Harriet Elson
Whirligig V

15" x 20" (38 cm x 51 cm)
Crescent 5115 watercolor board

facing page

I have found that no worthwhile art springs to life at will. Dauntless was the result of second thought and hopeful hunches.

Donald J. Phillips
Dauntless

28" x 20" (71 cm x 51 cm)
Arches 300 lb. rough surface

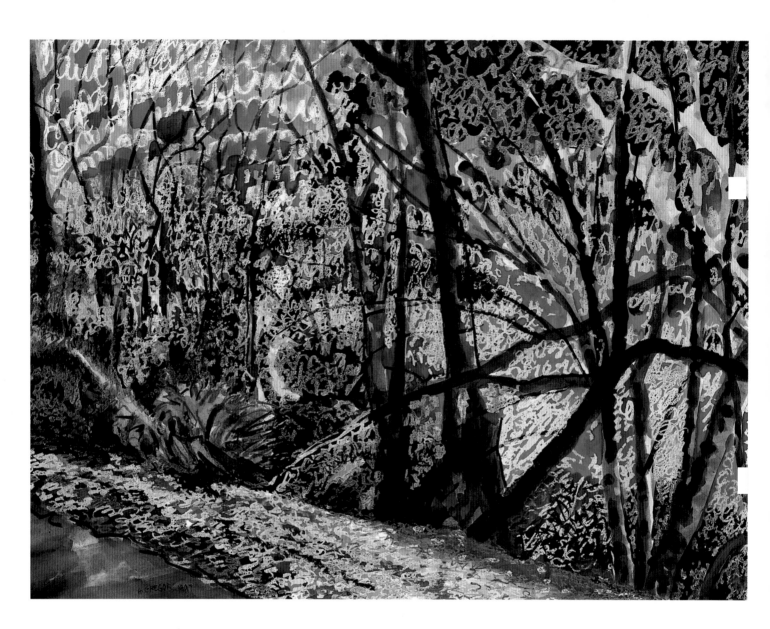

With this painting, I hoped to approximate the sensation of the expansive, energetic delight of experiencing a warm, sunny spring day outdoors after a long winter.

Harold Gregor
The Blue Shadow Side

18" × 24" (45.7 cm × 61 cm)
Arches 140 lb. hot press
Prang sixteen-cake watercolor

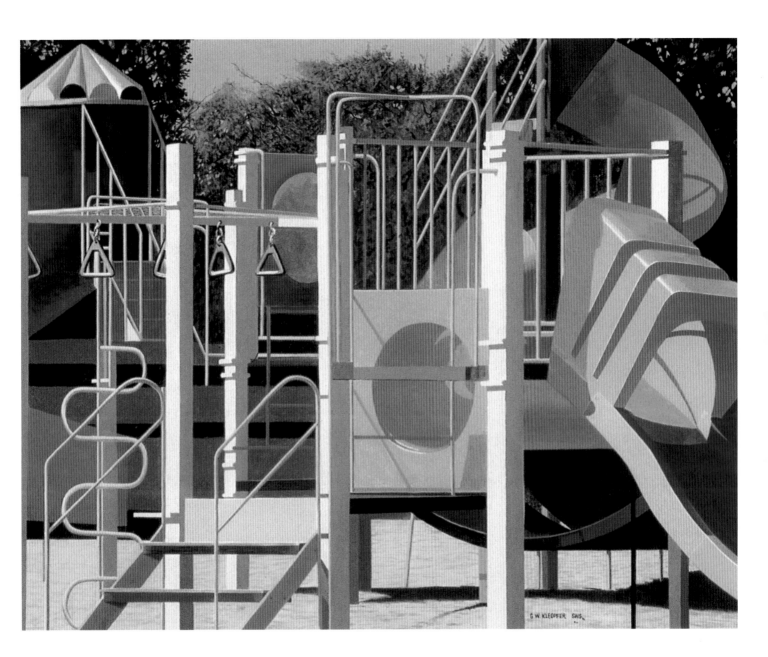

I was taking photographs of my grandson, George, playing and became overwhelmed by the colors and designs I was seeing through the camera lens. I knew I had to paint the scene. Unfortunately, poor little George got left out of the picture.

George W. Kleopfer Jr.
Corona Playground (Corona, California)

23.75" x 30" (60 cm x 76 cm)
Double-thick illustration board
Watercolor with acrylic

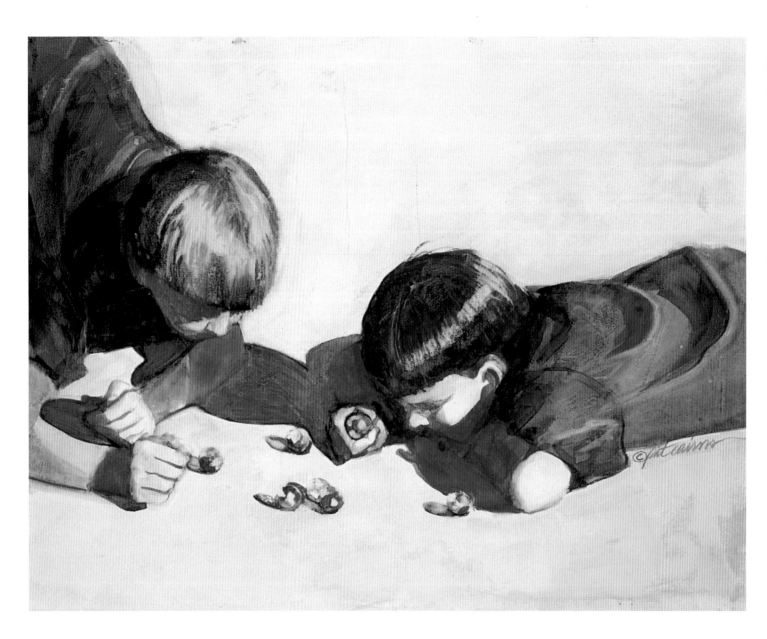

I wanted to express my joy in simple pleasures, like marbles on a sun-warmed sidewalk.

Pat Cairns
Marbles

22" x 30" (56 cm x 76 cm)
Arches 140 lb. hot press
Watercolor on gesso-coated paper

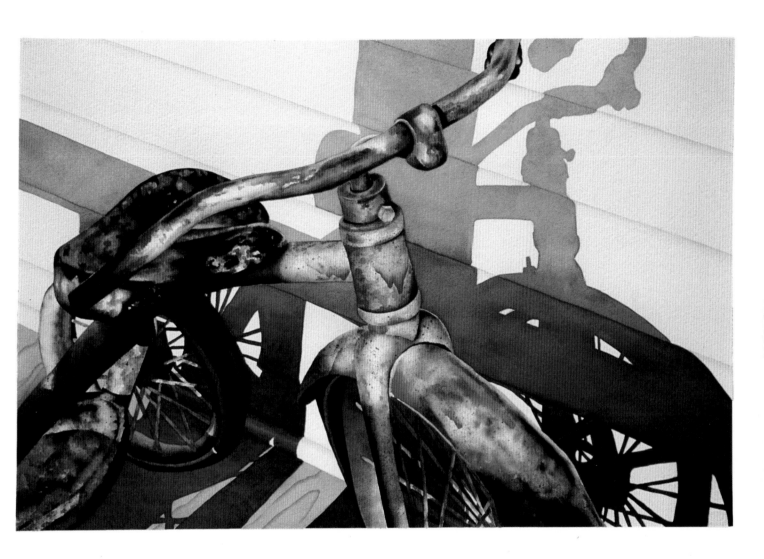

When I came across this tricycle on the porch of an old house recently, I couldn't help feeling a sense of nostalgia—a longing for a simpler time, when a child could be contented with a three-wheeled companion. I was inspired by the contrast of the rust, faded paint, and play of shadows against the smooth wood of the house.

D. Denghausen
A Tricycle Forgotten II

14" x 22" (36 cm x 56 cm)
Arches 300 lb. cold press

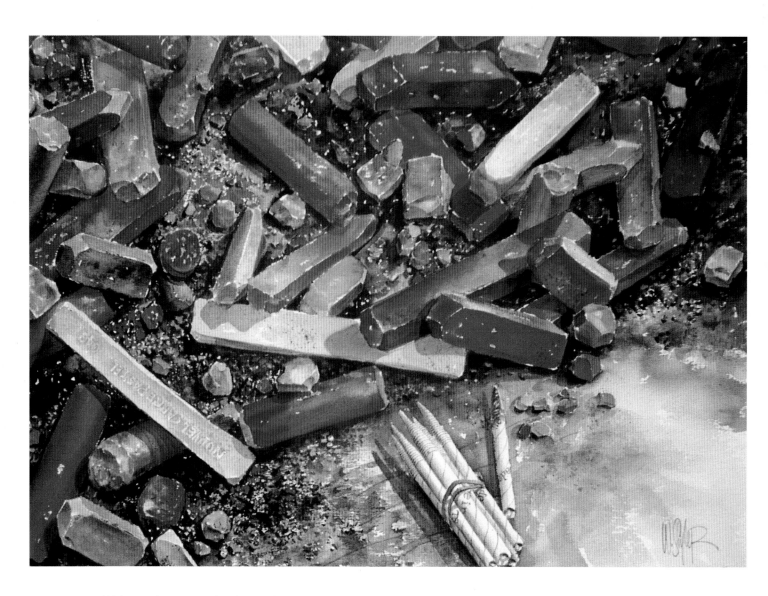

While completing a pastel commission, I was intrigued by the brilliant mix of colors and shadows created by the sunlight streaming through a window over my jumbled palette and immediately took several photos of the moment. The brilliant juxtaposition of colors, as well as the shadows, contributed to a feeling of jumbled movement. I started with a detailed drawing and painted from dark to light with the shadows and background forming the various shaped sticks, then rendered the individual sticks with a series of transparent washes.

Wayne Skyler
Pastel Palette

22" x 28" (56 cm x 71 cm)
Arches watercolor board, rough

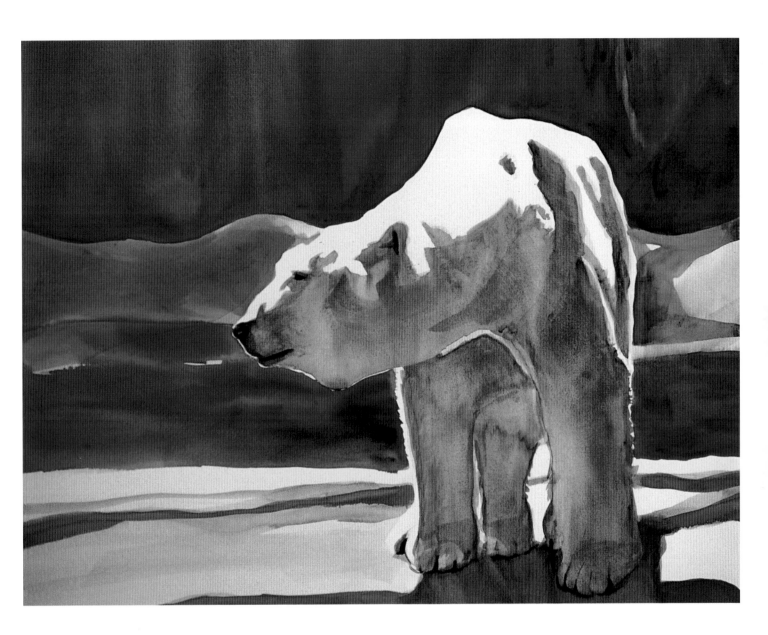

I spent many summers in Alaska and love the beauty of this state—from the forest to the desolate ice floes that the bears live on. I tried to depict the Northern Lights by using wet-in-wet painting upside down. Then on the fur, using mostly wet-in-wet, I dropped in color to depict the glow of the sky.

Colleen Newport Stevens
Midnight on the Ice

20" x 30" (51 cm x 76 cm)
Lanaquarelle 300 lb.

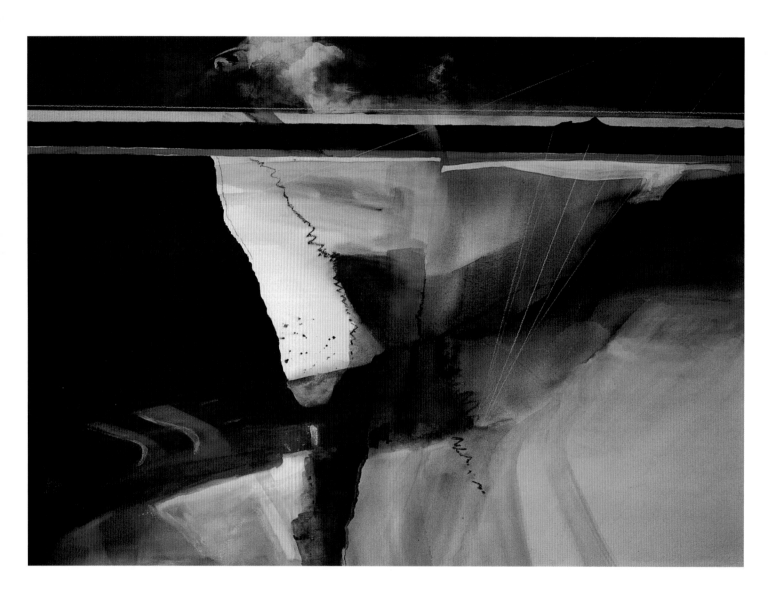

Knowing I wanted a feeling of space and drama, the painting developed rather quickly, even though the subject was not pre-planned. The painting represents hope and joy. The movement and space expresses an uplifting, soaring spirit.

Barbara Burwen
Awakening

22" × 30" (56 cm × 76 cm)
Watercolor with acrylic and watercolor pencil

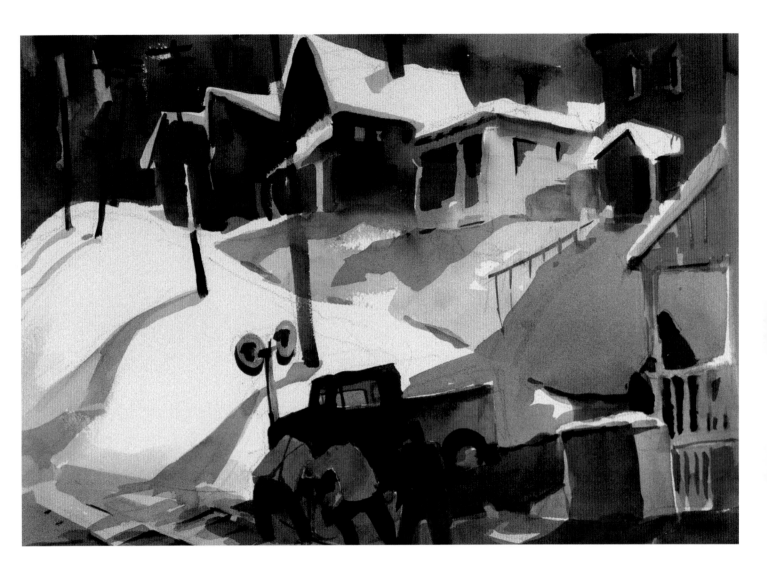

This painting's low-key color scheme evokes sad memories of a time during the Great Depression; people work and endure in the shadows of a late-winter afternoon. But even so, there is promise for the future as the road turns and rises toward the sunlight.

Edwin C. Shuttleworth
Grade Crossing

14.5" x 21.5" (37 cm x 55 cm)
Arches 140 lb. cold press

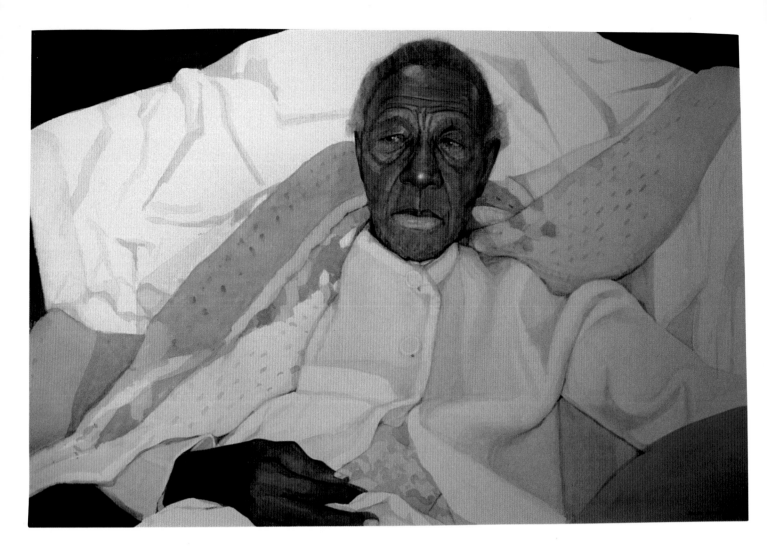

This painting is about sorrow. On her final visit to my home, Rowena was too weak to walk. She worried that I might hurt my back carrying her inside. She was so frail, so thin. She was as easy to carry as a memory.

Dean Mitchell
Rowena's Last Visit

20" x 30" (51 cm x 76 cm)
Crescent hot-press watercolor board

facing page

In this painting, I used a white-on-white theme to represent the joy of pure, unadorned elegance. Sensual glazes of warm and cool shadow colors enhance the work's ethereal quality.

Pat Fortunato
Material Pleasures #5

30" x 22" (76 cm x 56 cm)
Waterford 200 lb.

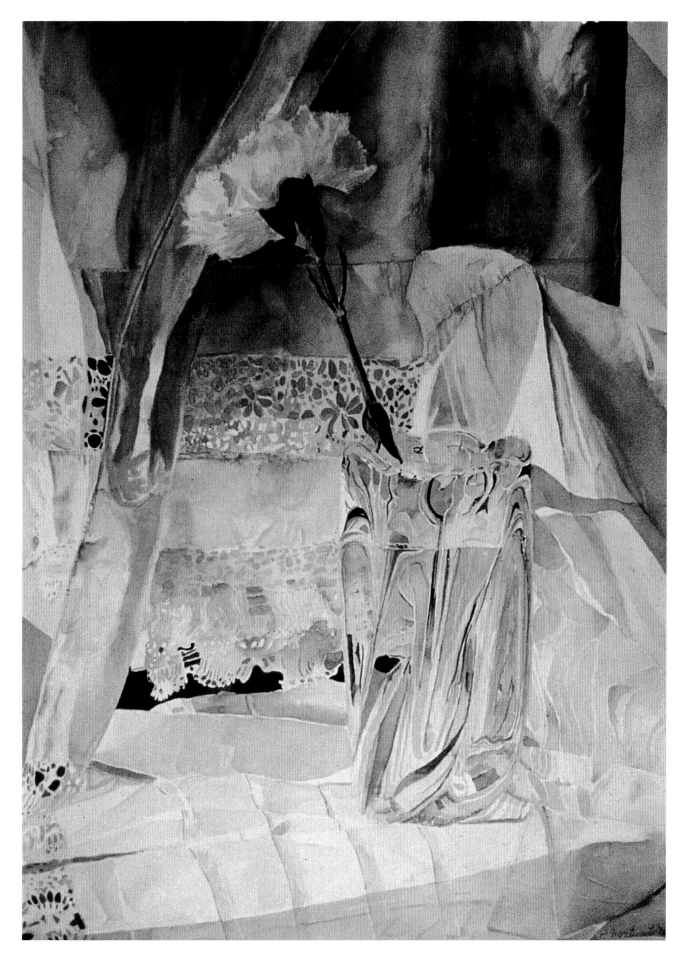

The snow came overnight in November. It was 8:30 AM when I drove past Route 55 near Chenoa, off the main highway. The mood was clear and silent, very peaceful.

Benjamin Mau
Illinois Winter

30" x 40" (76 cm x 102 cm)
Arches 140 lb. cold press

facing page

The world we live in today whirls by at an incredible pace. Days are jammed with work, chores, errands, meals, and what seems like a hundred other things. The more our life speeds up, the more we feel weary, overwhelmed, and lost. Coming Around Again is a painting that speaks to these feelings.

Carla O'Connor
Coming Around Again

30" x 22" (76 cm x 56 cm)
140 lb. hot-press watercolor paper
Watercolor with gouache

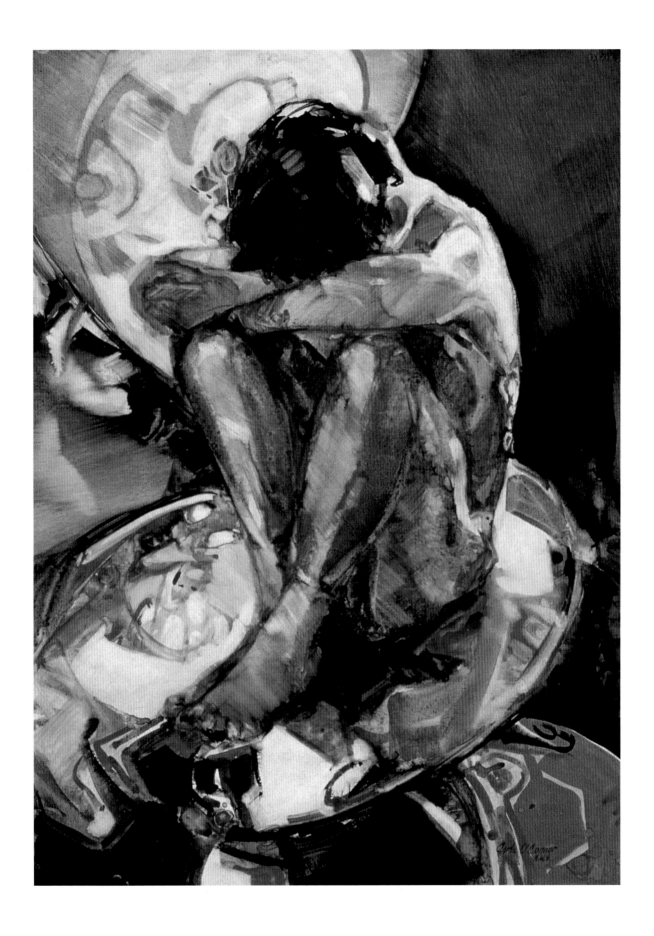

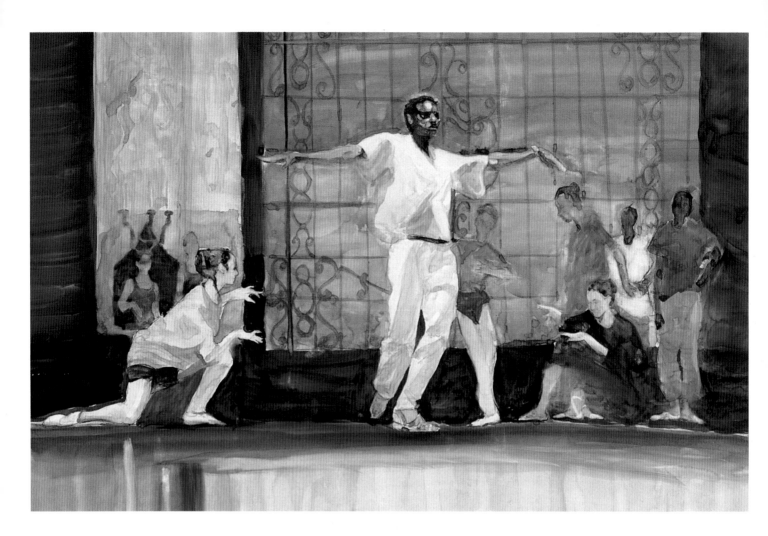

I had the privilege of observing and sketching these ballet dancers while they rehearsed. For me, it is an amazing experience, but for them it is just a moment in their day. Later that evening, the performance was superb.

Rhoda Yanow
Rehearsal

29.5" x 34" (75 cm x 86 cm)
Strathmore bristol board plate surface

facing page

My "Contemplation of Flight" series originated from my interest in the universality of the desire to fly. I enjoy exploring various images of flight as symbols for freedom, transformation, transcendence, spirituality, and creativity. In Birthstone, I juxtaposed the contrasting images of wing and feather against stone texture and blocks. The winged Victory figure was sculpted from marble, its spirit given wings by the artist. Like Victory, we transcend our constraints and limitations through flight: physical, mental, spiritual, or creative.

Kathleen Conover
Contemplation of Flight: Birthstone

40" x 32" (102 cm x 81 cm)
Acid-free foam-core board cold press
Watercolor with acrylic, gouache, and Caran D'Ache

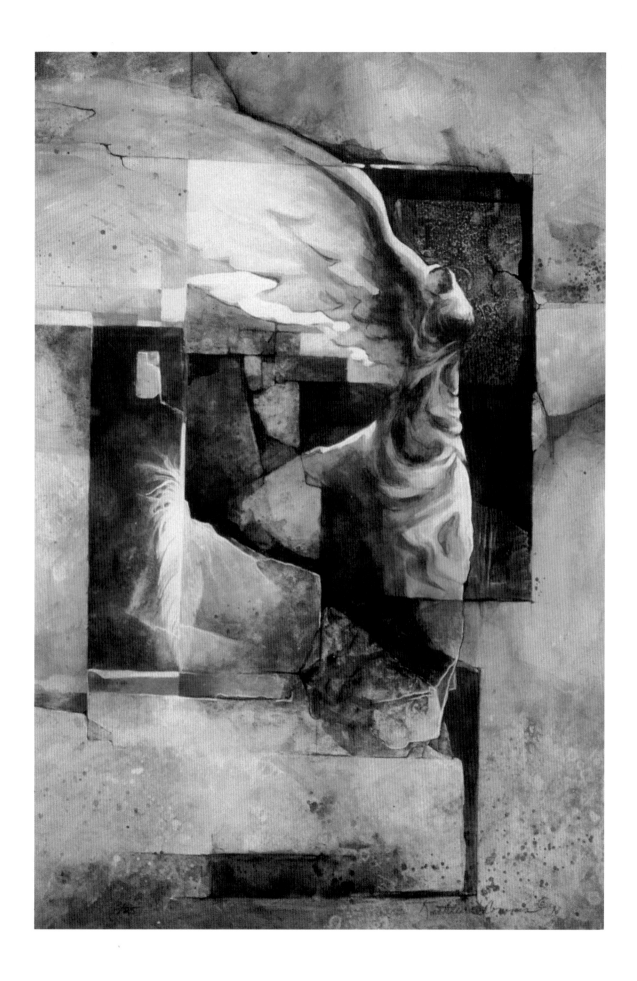

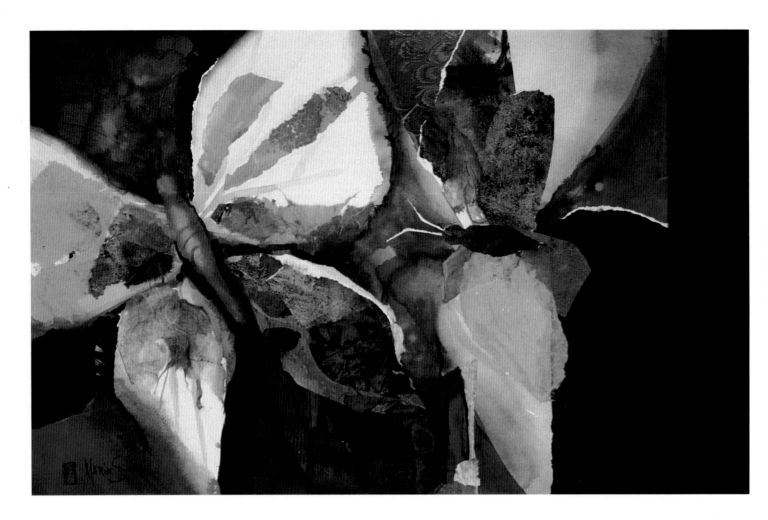

Butterflies are free and beautiful, and they epitomize the spirit and awakening of springtime. The greens in this painting represent life and rebirth, symbolizing hope.

Marie Shell
Butterfly Series #11: Soul Mates

22" x 30" (56 cm x 76 cm)
Arches 300 lb. cold press
Watercolor with gouache and powdered metallics

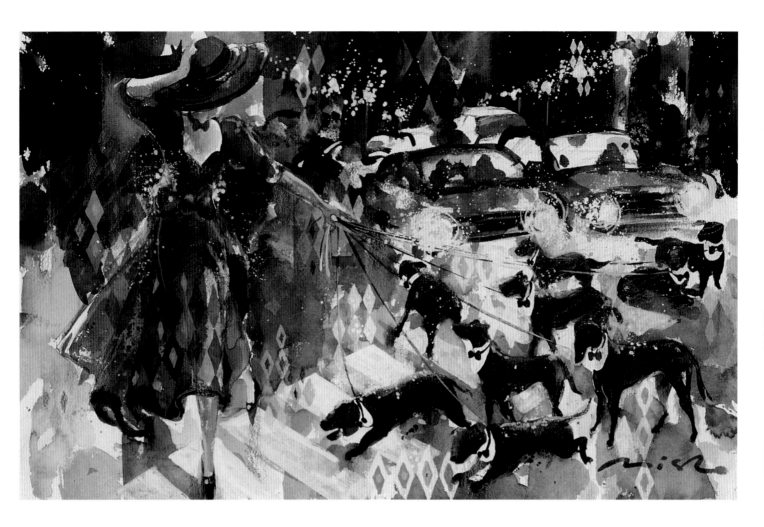

The playful subject matter of this piece projects a carefree mood. The monochromatic backdrop of the painting focuses the eye on the splash of red that is the woman's dress. She holds a hat that is at risk of being swept away by the wind. Yet she is in control, stopping the traffic and leading the dogs across the street. The woman represents glamour and grace, which are my common focal points as an artist and a lover of fashion.

Misha Lenn
Gala Evening

13" x 20.5" (33 cm x 52 cm)
Arches 140 lb. cold press
Watercolor with white tempera

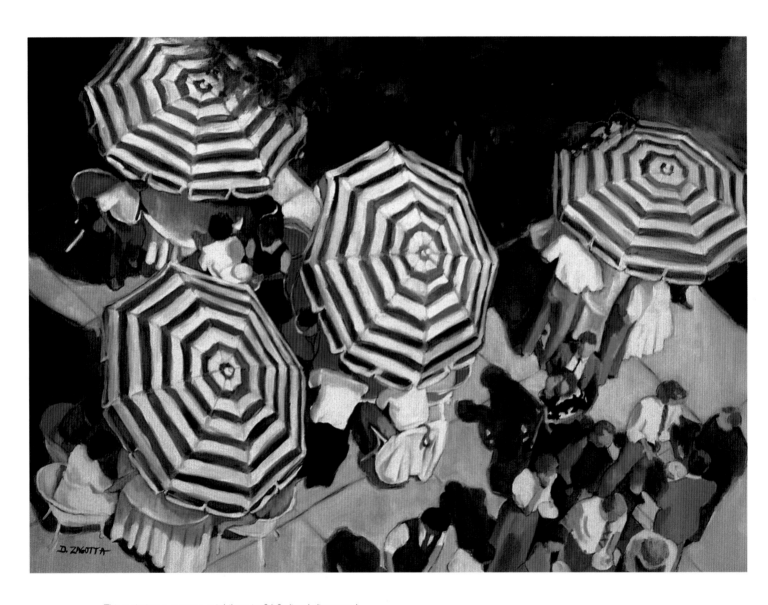

This painting expresses a jubilant, joyful feeling. I discovered the subject when I looked out of our hotel-room window and saw a wedding party taking place in the garden below. I conveyed the mood with contrasts—contrasts of complementary colors (such as red-violet and yellow-green), of light and dark values, and of simple areas with patterned ones.

Donna Zagotta
Garden Party

22" x 30" (56 cm x 76 cm)
Lanaquarelle 140 lb. hot press
Watercolor with gouache and Caran D'Ache crayons

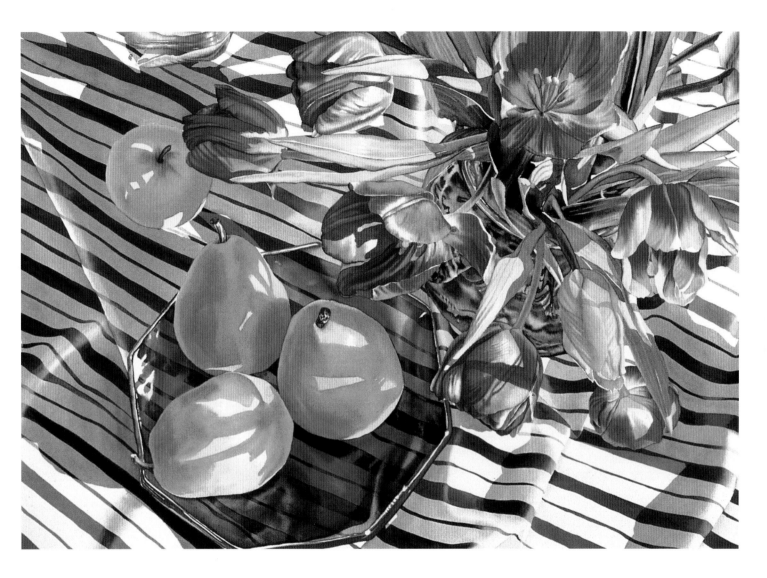

Color is a powerful and provocative thing that infuses paintings with vitality and energy. Light, however, is what truly gives the work life. I feel that the emotional connection is made with, and the true beauty lies in, the qualities of light that dance over, in, and through the objects.

Judy Bates
Tulips, Pears, and Cobalt Plate

29.5" x 40" (75 cm x 102 cm)
300 lb. cold press

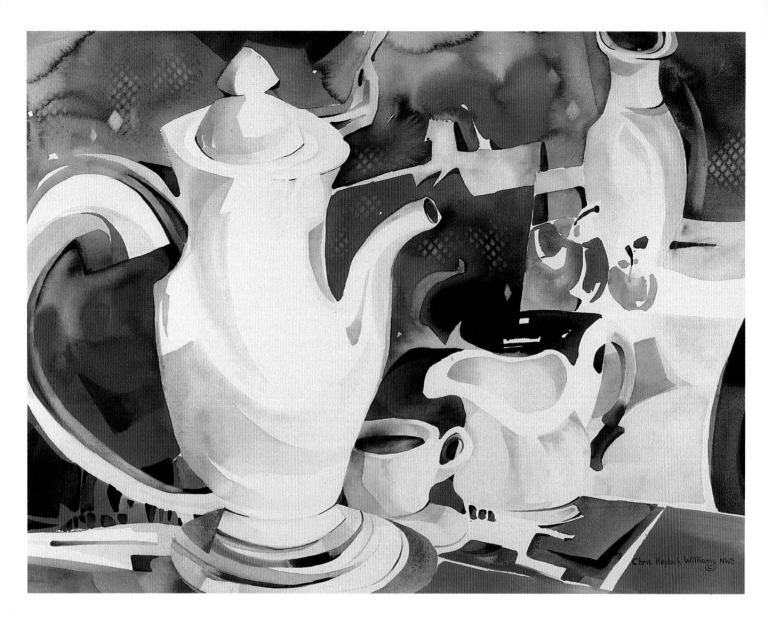

Having a cup of coffee, perhaps sharing it with a friend, is one of life's small daily pleasures. It's a warm, friendly, uplifting event, and I delighted in the experience of bringing cheer and dynamism into my painting.

Chris Keylock Williams
Coffee Connection

21" x 29" (53 cm x 74 cm)
Arches 140 lb. rough

facing page

A Berkeley Blend is a painting of my son. We were at a small café in Big Sur, California, enjoying a cup of freshly ground Berkeley Blend coffee. I took photographs to create a painting full of mystery and dramatic light.

June Young
A Berkeley Blend

21" x 13" (53 cm x 33 cm)
Arches 140 lb.

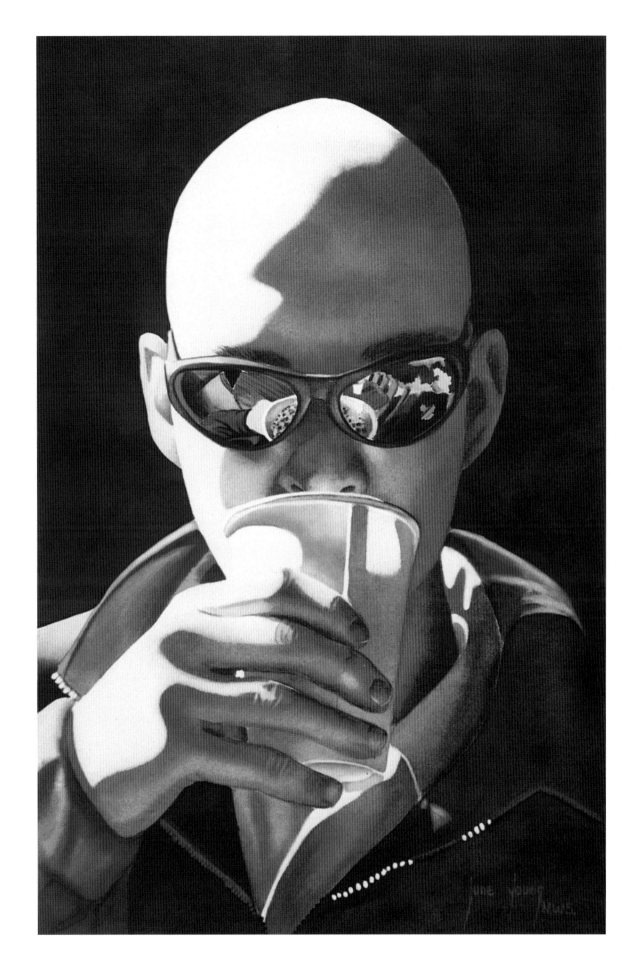

My work reflects my sadness at this city's loss of industry along
with my wonder at nature's ability to reclaim man's creations.

Jay Kelly
Stockton Ave./Jersey City, NJ

10" x 19" (25.4 cm x 48.3 cm)
Fabriano Artistico 300 lb. hot press

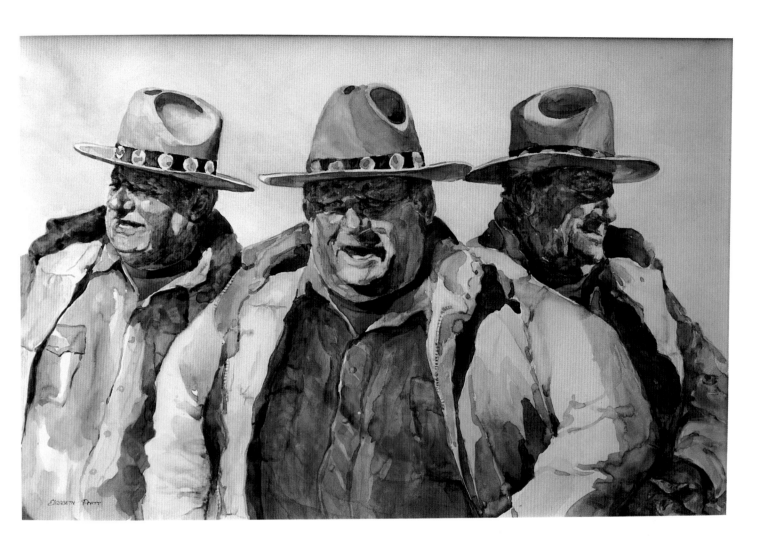

In this subject, I saw a face and physique that emanated great
energy and a positive life force. The hat made good shadows
on his face, and the jacket lapels provided strong vertical lines,
reinforcing Vito's vitality.

Elizabeth Pratt
Vito

20" x 29" (51 cm x 74 cm)
Strathmore 500 series hot press

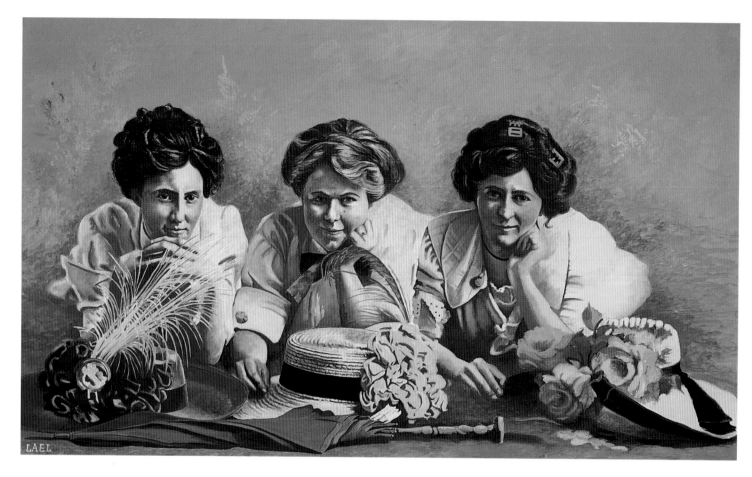

I think the hats in this painting are very festive—you can tell the women are dressed in their best finery, and I wanted to show the beauty of the scene. So, I laid out real roses for the hat that has roses. The background included ferns and small wildflowers pressed into the paint for a soft effect.

Lael Nelson
Easter Bonnets

19" x 29" (49 cm x 74 cm)
Watercolor board

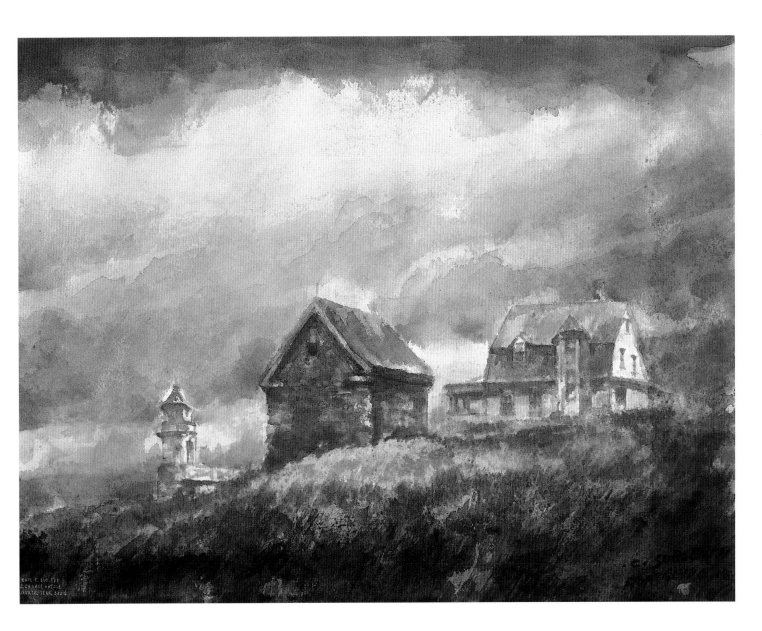

My compositions often pursue the thrill of the moment. If they succeed in recording nature's light and movement, they convey a strong sense of place.

Carl Sublett
Sunny Fog: Autumn Field

18" x 24" (46 cm x 61 cm)
Arches 140 lb. rough cotton

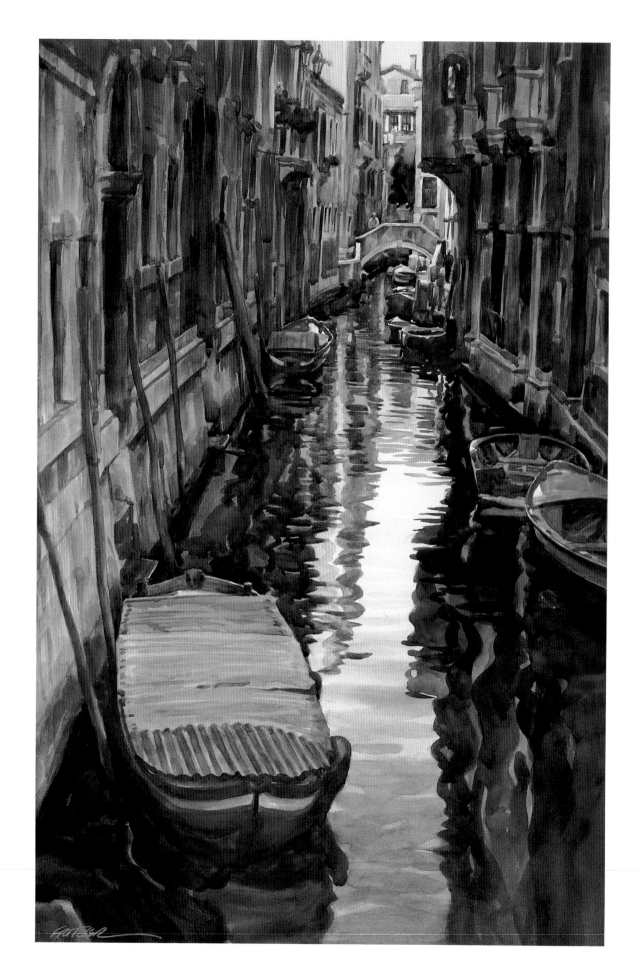

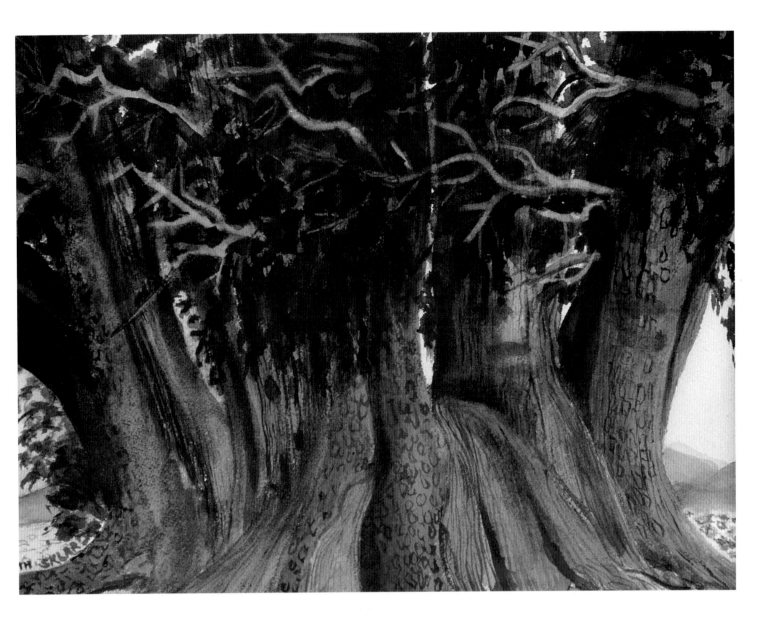

I feel great admiration for this sturdy ancient tree, and I took great pleasure in re-creating the texture of its twisted wood.

Ruth Sklar
Bristle-Cone Pine

10.5" x 14" (27 cm x 36 cm)
Arches 140 lb. cold press

facing page

In Venice, Italy, there are many canals, but only a few that I feel really capture the flavor of this great city. This small canal embodied the quiet beauty of the Venetian light as it reflects the shapes of bridges, boats, and buildings.

Gerald Fritzler
Venetian Canal

27.5" x 18.25" (69.75 cm x 46.25 cm)
Crescent 5115 watercolor hot-press board

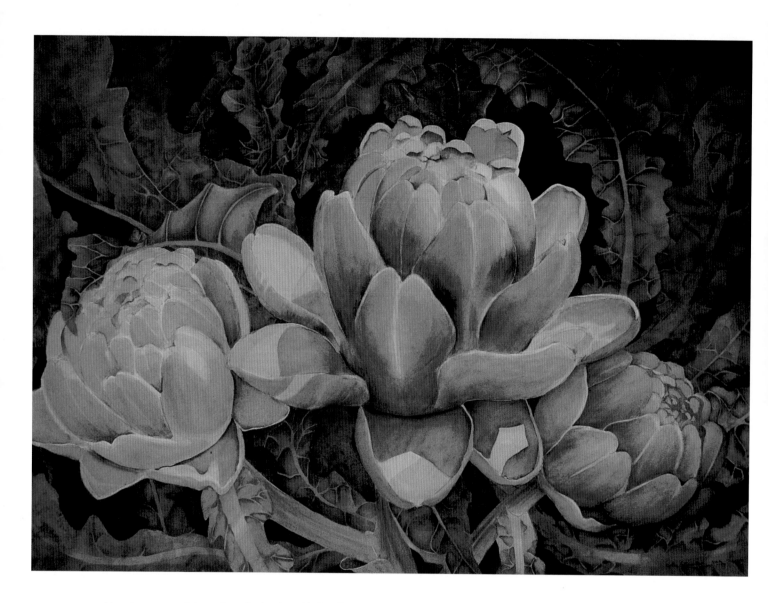

I love to capture all the variety of colors in artichokes, from yellows to blues to browns. The blue-greens in these artichokes really spoke to me.

Cynthia Eastman-Roan
Artichokes II

21" x 29" (53 cm x 74 cm)
Arches 300 lb. cold press

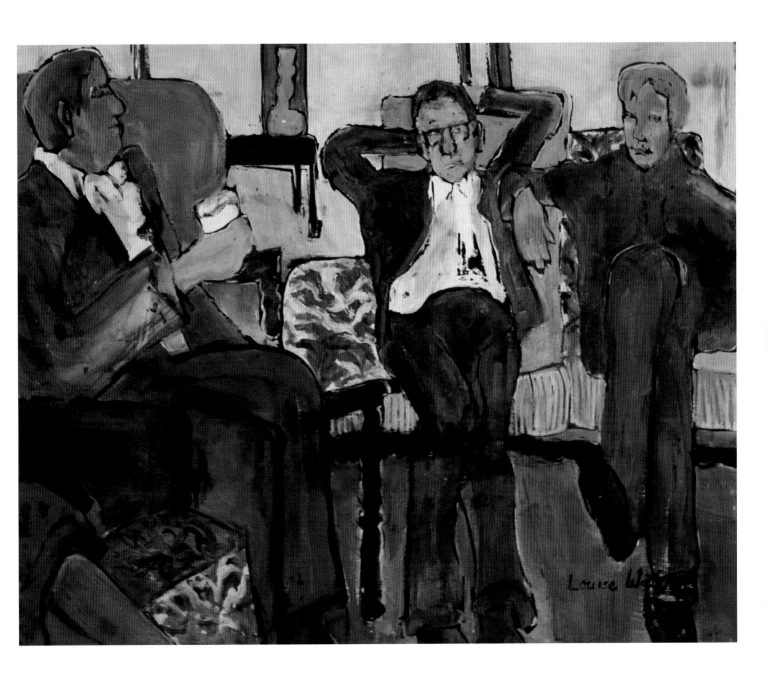

I like to sketch people. In this case, I saw these people having drinks and conservation before dinner. They looked contented and at ease in the world.

Louise Waters
Conversation

32" x 40" (81 cm x 102 cm)
Illustration board

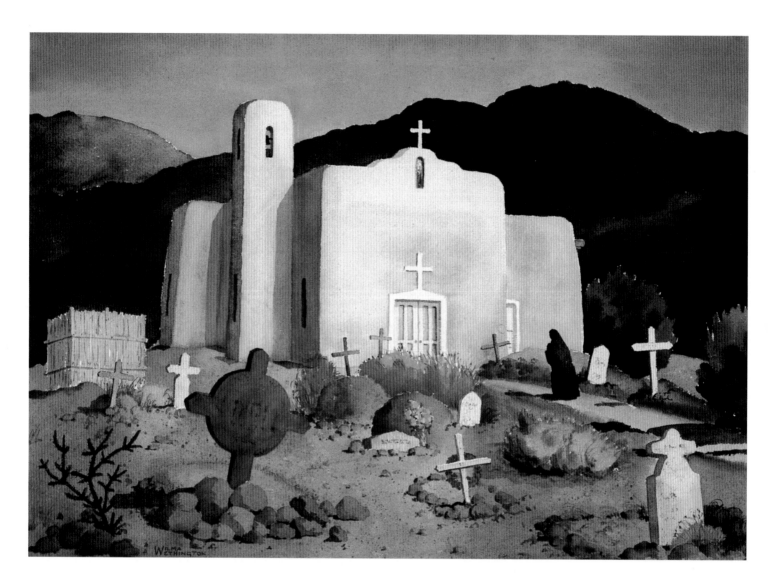

The emotion I felt while painting this old mission was complete sorrow. As I walked around looking at each grave, I could not help but feel sorry for these very poor people who had tried so hard to honor their dead in their own crude way.

Wilma Wethington
The Mission at Golden (Golden, New Mexico)

21.5" x 30" (55 cm x 76 cm)
Arches 300 lb. cold press

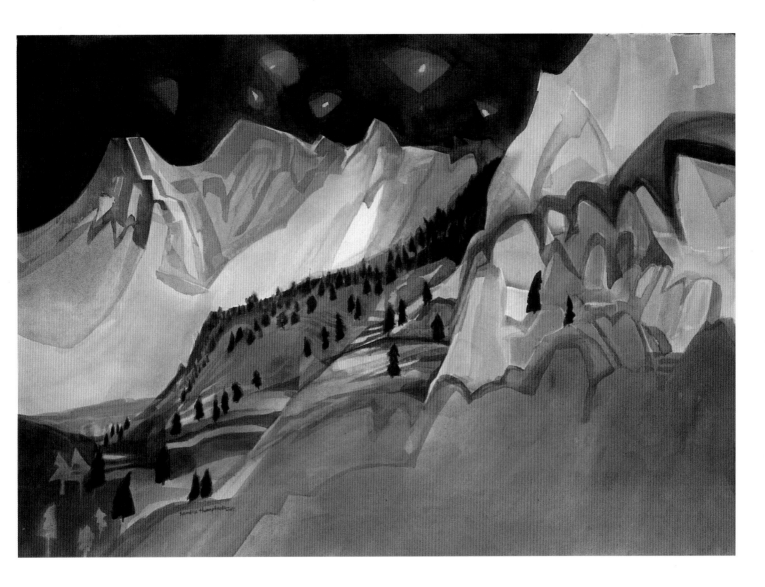

I used to live close to the Sandia Mountains, and this painting recalls the mystery of the moonlight as it lit up the mountains and sky. It inspires a feeling of wonder and awe. In this painting, I wanted drama and romance, and I wasn't particularly interested in detail or realistic color.

Sandra Humphries
Starlight

29" x 41" (74 cm x 104 cm)
Arches cold press
Watercolor with acrylic

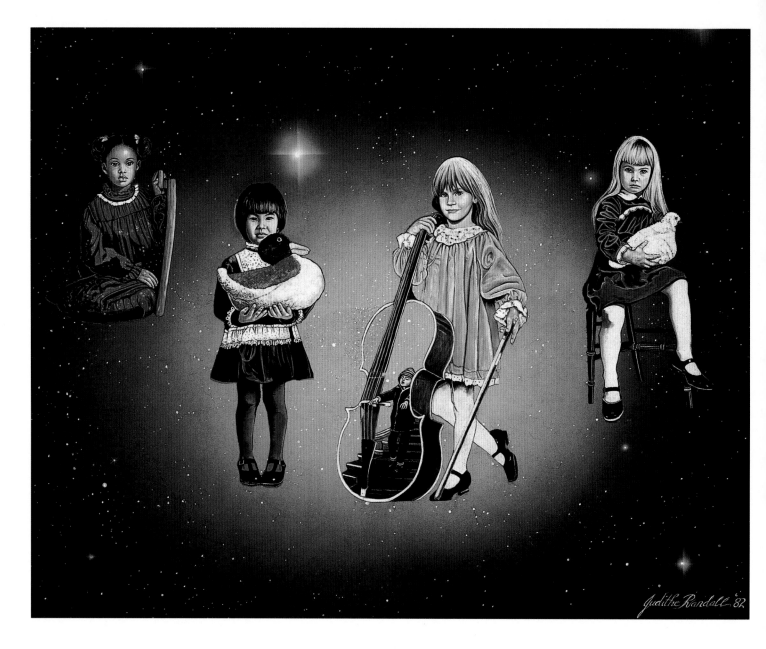

*My painting represents hope. The four little girls represent a
"rainbow coalition" of races and types waiting for the world to
catch up with their dreams.*

Judithe Randall
All God's Children

20" × 28" (51 cm × 71 cm)
Crescent Cardboard Illustration Board
Watercolor, acrylic, and ink

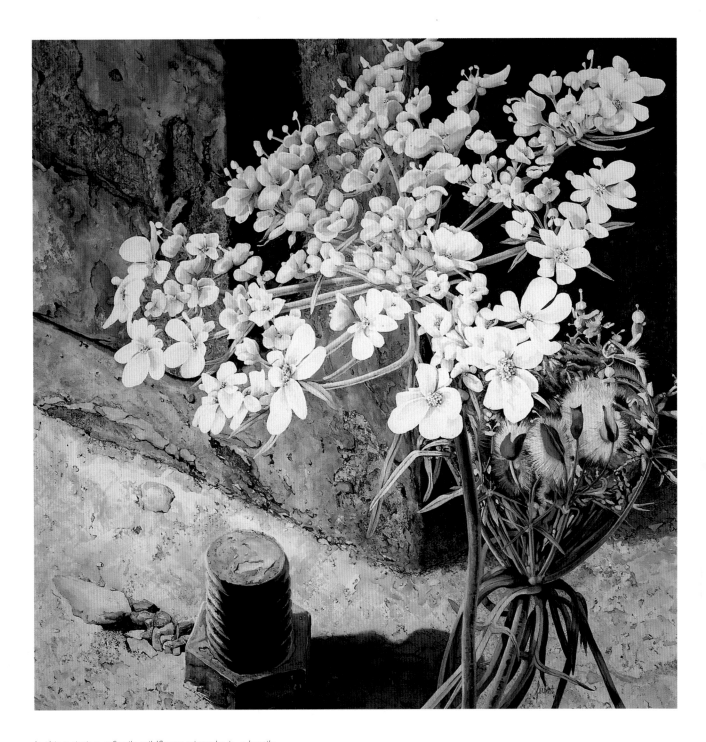

In this painting, a fragile wildflower triumphs in a hostile environment. I draw inspiration from Cleveland's Flats, the industrial banks of the Cuyahoga River. Hardy wildflowers are now invading what was once the domain of the Rust Belt. Their inherent adaptability enables them to participate in the evolution of the area. As a naturalist and painter, I succumbed to their indomitable beauty.

Mary Lou Ferbert
Queen Anne's Lace at the Bridge

48" x 48" (122 cm x 122 cm)
Arches

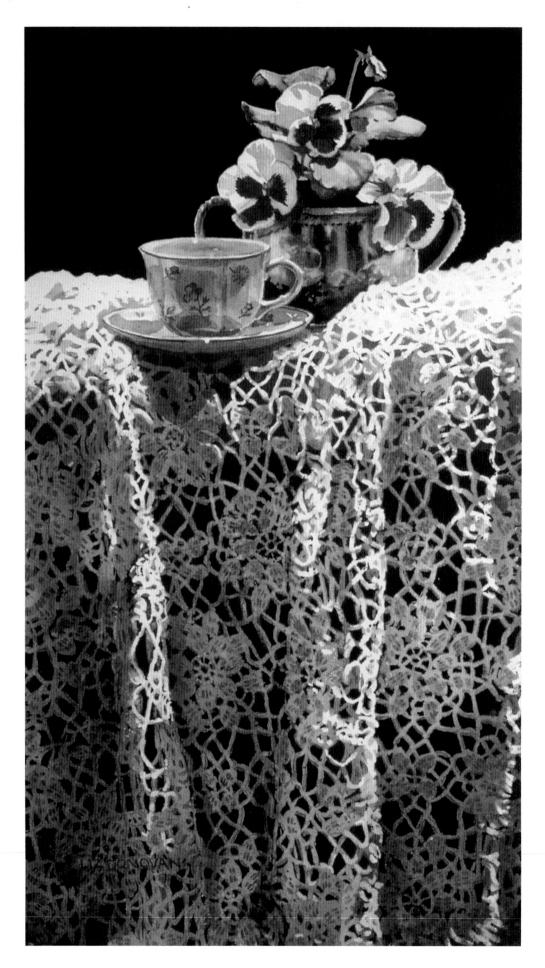

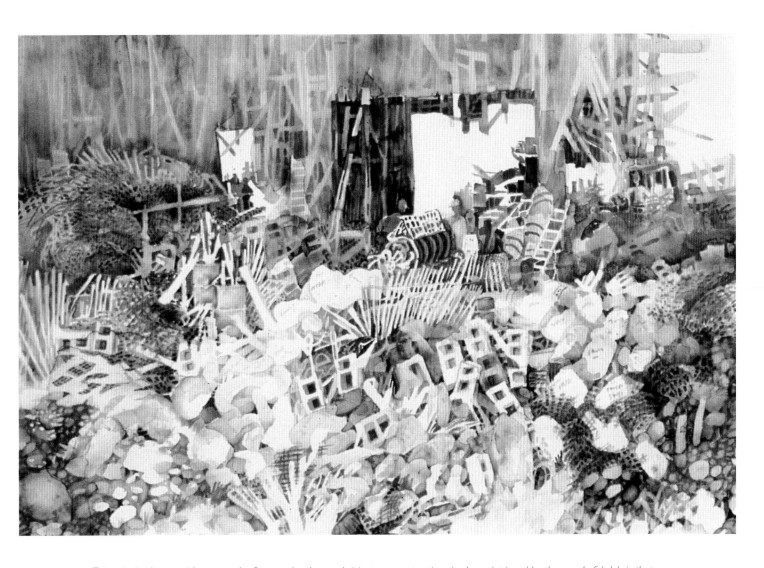

This painting began with repeated reference sketches and visits to a construction site. I was intrigued by the wonderful debris that littered the area and re-created the effect using negative glazes. The activity of the many negative shapes expresses the true spirit of this construction site.

Lorna Berlin
Construction Site #6

22" x 30" (56 cm x 76 cm)
Fabriano 140 lb. cold press

facing page

Placing the objects at the very top of this elongated painting gives the viewer the feeling of looking up at them, making them more important. It also provides a large area to show off the intricate lace pattern of the cloth. I painted the pattern in layers, first applying a loose wash of warms and darks that described the folds. The lace was "drawn" with liquid mask and followed up with a very dark wash that also became the background.

Liz Donovan
Pansies with Teacup

24.25" x 14" (61.5 cm x 36 cm)
Arches 300 lb. cold press

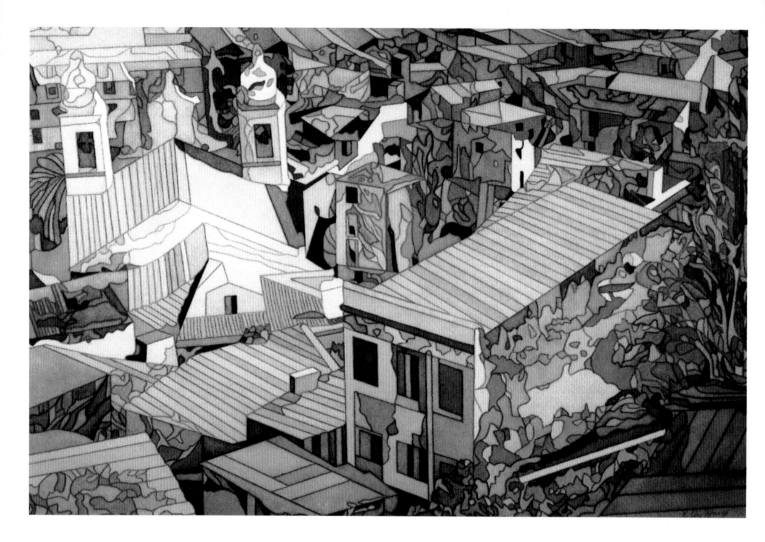

After my trip to Portugal, I found a forgotten picture in my photo album. The joy of remembering my visit there inspired me to do this watercolor.

Robert DiMarzo
Portuguese Town

14.25" x 19.75" (37 cm x 50 cm)
Smooth 140 lb. 100% rag cold press

facing page

The family unit in rural America not only represents the substance of success, but also is the heart and soul of Heartland culture. Heartland *is a painting about success— success defined in the most human terms.*

Robert L. Barnum
Heartland

32" x 24" (81 cm x 61 cm)
Double Elephant 550 lb. cold press

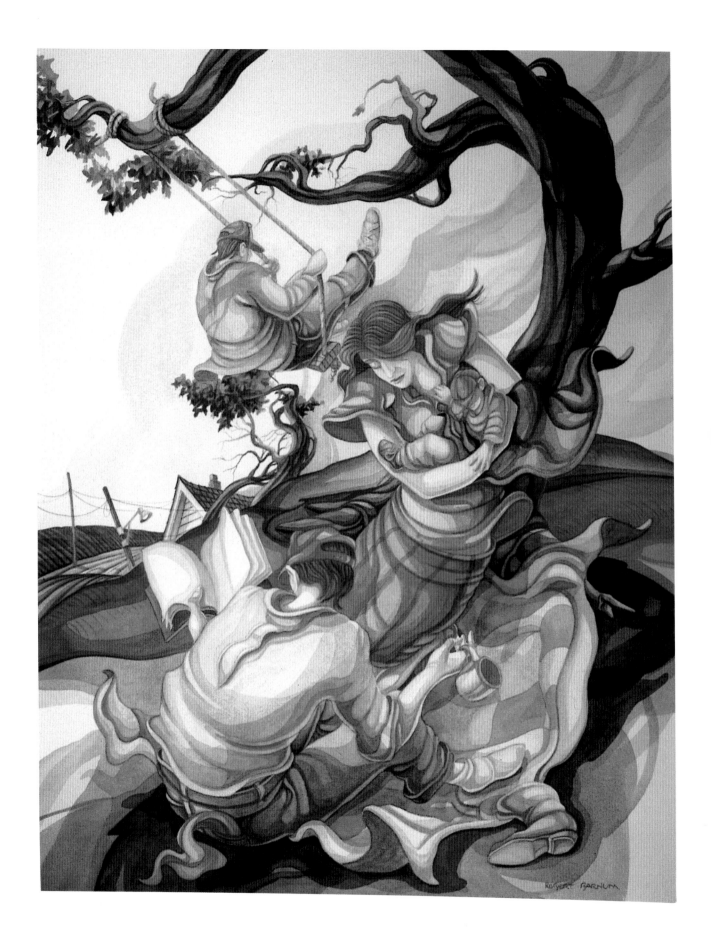

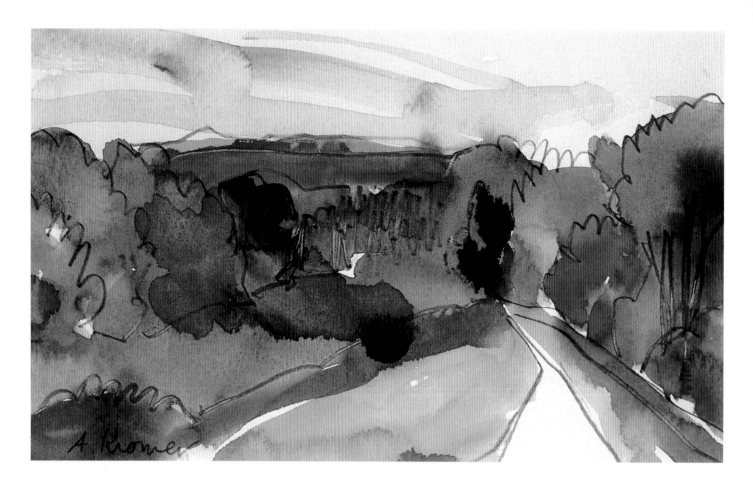

A feeling of melancholy infuses this painting because the month of September brings subtle colors and the anticipation of a long, cold winter.

Ann Kromer
September

11" x 14" (28 cm x 36 cm)
Canson watercolor block
140 lb. cold press

facing page

Once I start painting pears, I am lost in the exciting rhythmical designs that evolve. I could paint pears forever and never become bored.

Eileen Monaghan Whitaker
The Pear Theme

22.25" x 16" (56.5 cm x 41 cm)
300 lb. watercolor paper

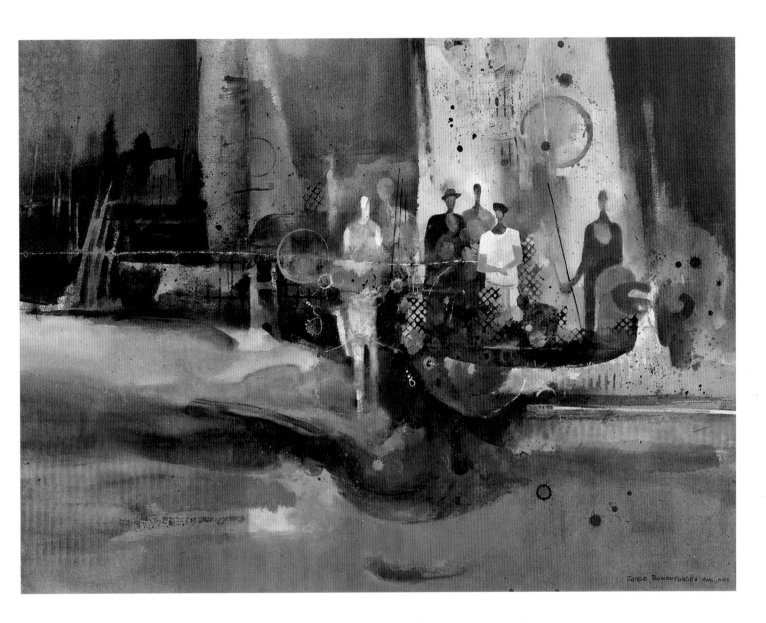

Ancient Mariners, *as does most of my work, evolved essentially by way of invention and memory. I believe that the abstract elements in a work are more important to the success of the work than how accurately the illusion of reality is presented. I therefore start out working in transparent watercolors and with no fixed idea in mind. Toward the end, I use a mixture with gesso to give a feeling of solidity where needed.*

Jorge Bowenforbés
Ancient Mariners

22" x 30" (56 cm x 76 cm)
Arches 140 lb. cold press
Watercolor with gesso

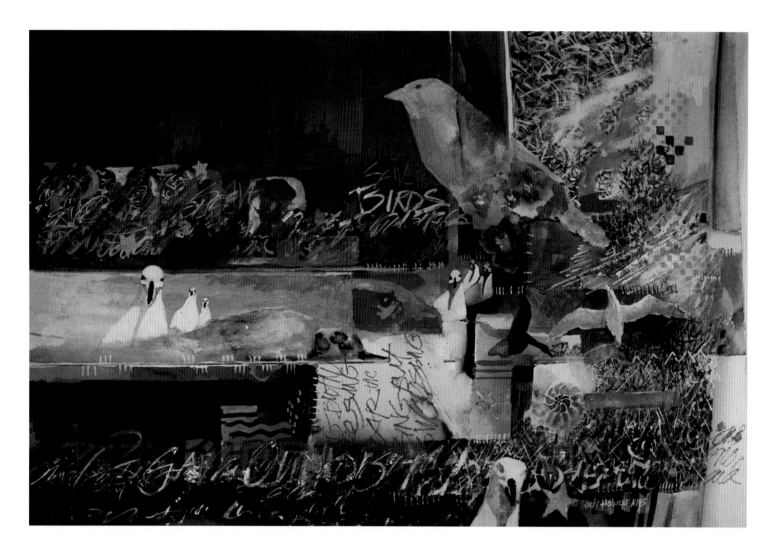

I wanted to inspire compassion on the part of the viewer, but I didn't want to be heavy-handed in my approach. So I used an abstract gestural script that functions as a visual texture rather than a legible message. This script works around, over, and under recognizable images.

Judy Hoiness
Land and Sea Series: Save Our Birds II

22" x 30" (56 cm x 76 cm)
300 lb. cold press
Watercolor with gouache

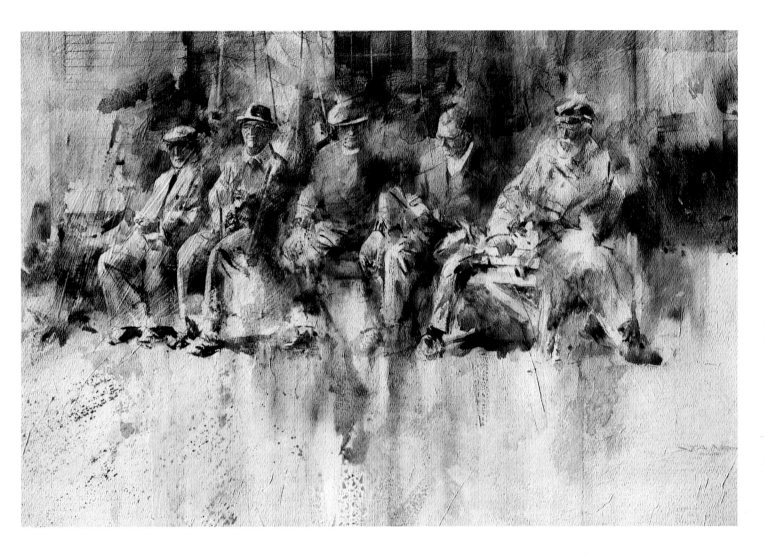

I want the viewer to imagine the goodwill and lighthearted rapport between the fishermen and the bystanders.

John A. Neff
Liar's Bench

18.25" x 27.25" (46.5 cm x 69.5 cm)
Watercolor board, surface tissue for texture

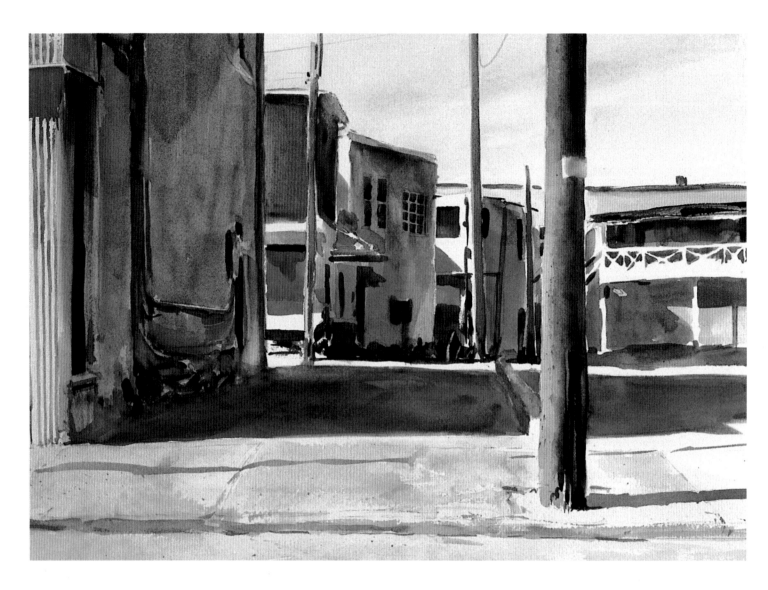

The low angle of the light, the absence of people, and slight air of urban decay combine, for me, to express a kind of loneliness—a good kind of loneliness. It's the way the world looks to the kid who delivers your morning paper.

Bill Teitsworth
Pink Motel

15" x 22" (38 cm x 56 cm)
Arches 140 lb. cold press

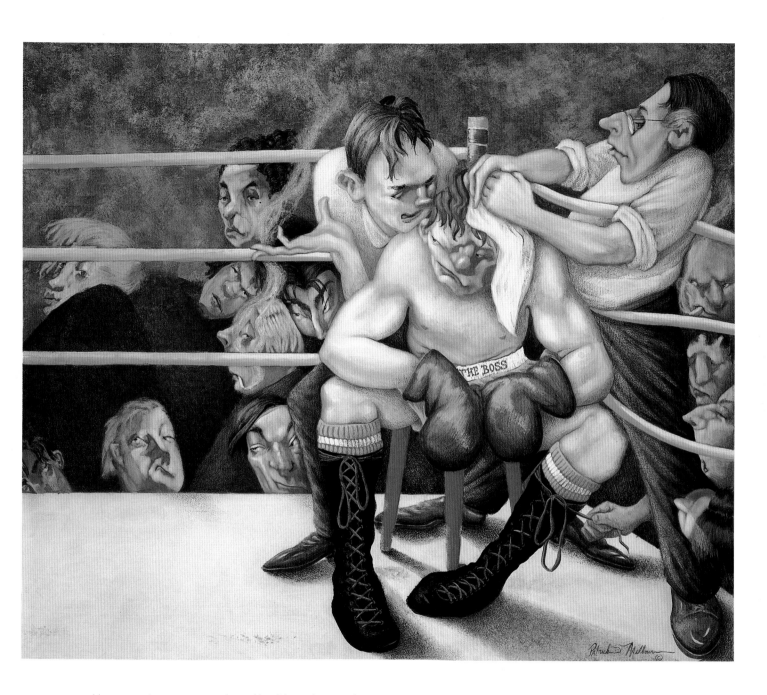

I love entertainment scenes—they add activity and a natural
drama to a picture. This piece takes place in a boxing ring.
The humor comes out of the crowd scene—truly a bunch of
characters. But the painting also has to do with hope. In boxing,
each round can bring disaster, so the fighters look for that one
window of opportunity for success, or at least survival.

Patrick D. Milbourn
The Boss

30" x 40" (76 cm x 102 cm)
Arches 300 lb. hot press
Watercolor with gouache

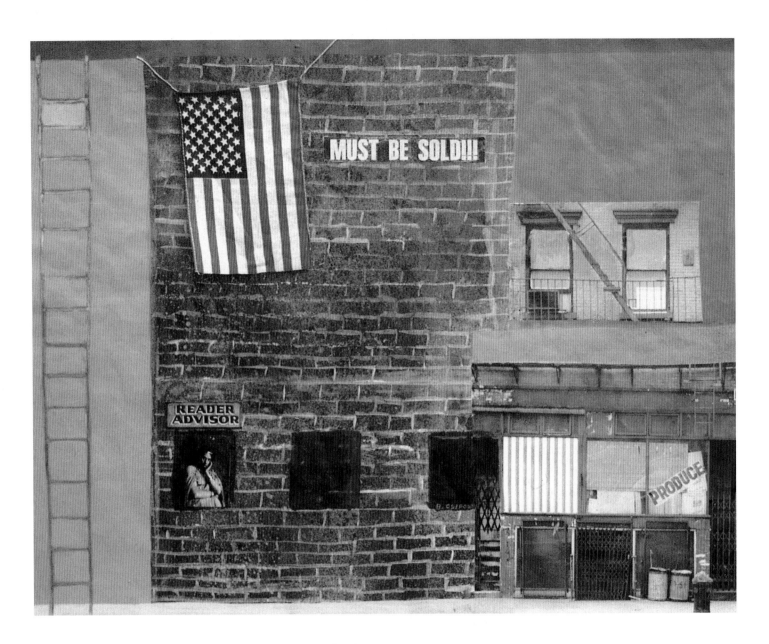

My emotions in this work are mixed and complex. I feel the anxiety and frustration of the owner of the building. I feel the pride of the immigrants who live above the grocery store and manage to make a meager living. I feel the sadness of the psychic who looks out her window waiting for a customer. In contrast, the flag represents my sense of hope.

Belle Osipow
Must Be Sold

18.75" x 24" (48 cm x 61 cm)
Arches 140 lb.
Watercolor with acrylic and collage

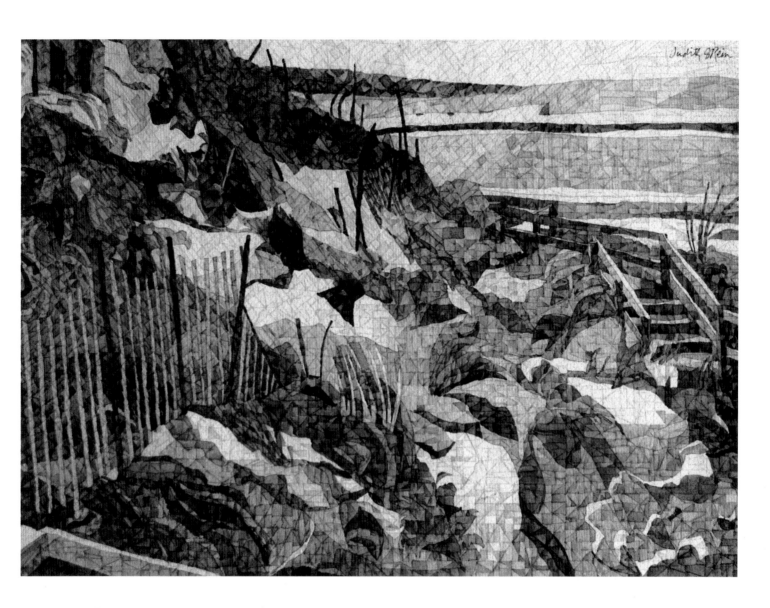

For me, this painting evokes a sense of homecoming of the place where I grew up. I painted this view of the Indiana dunes on southern Lake Michigan from my own photographs.

Judith S. Rein
Indiana Dunescape

10" × 14" (25 cm × 36 cm)
Canson Mi-Teinte, cream

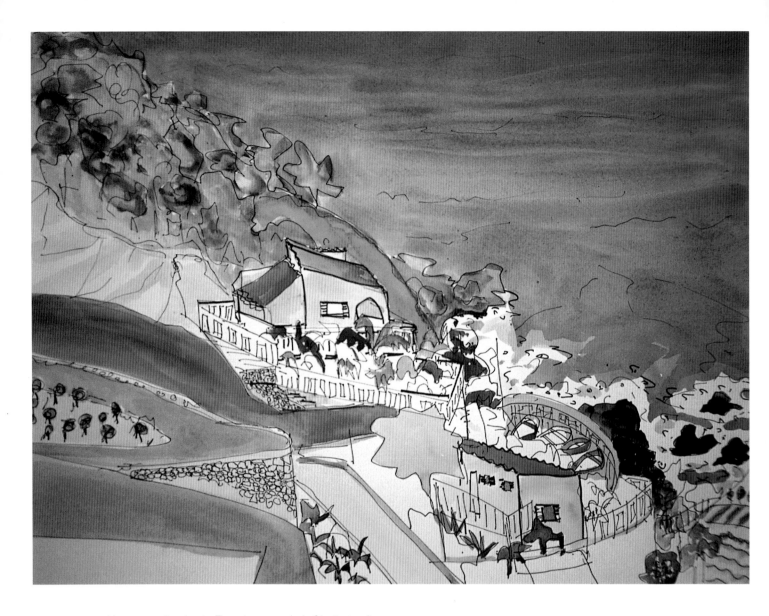

I love to travel and paint. There is a great deal of joy in standing in front of a new site and reading it with my brush.

Lynn Leon Loscutoff
Majorica Trip I

18" x 20" (46 cm x 51 cm)
Hot press
Watercolor with ink

facing page

Follow Me was a quick gesture drawing that just fell into place. I enjoy drawing and painting figures moving quickly, as in sports or musical events.

Charles I. Stratmann
Follow Me

28" x 20" (71 cm x 51 cm)
Arches 140 lb. cold press

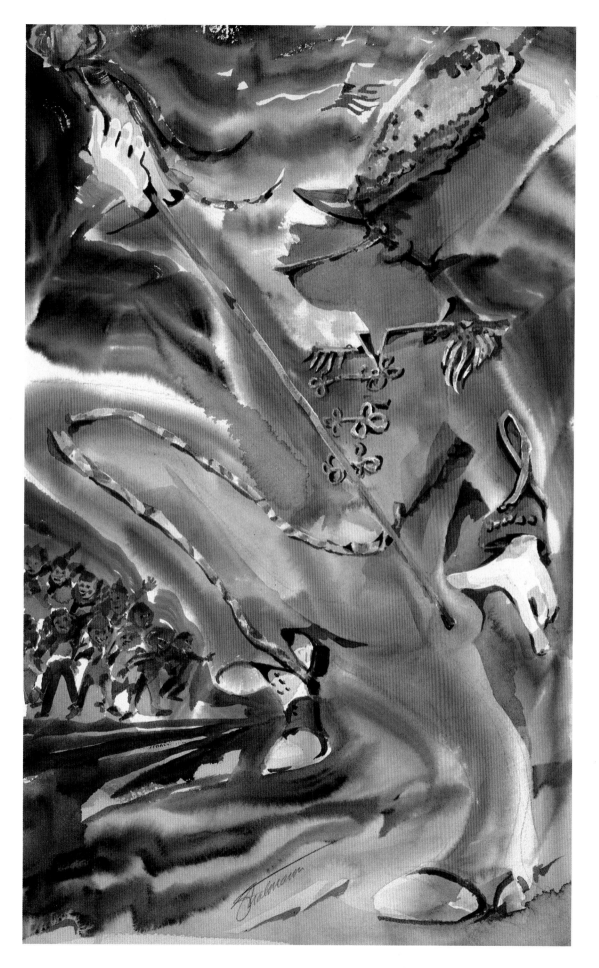

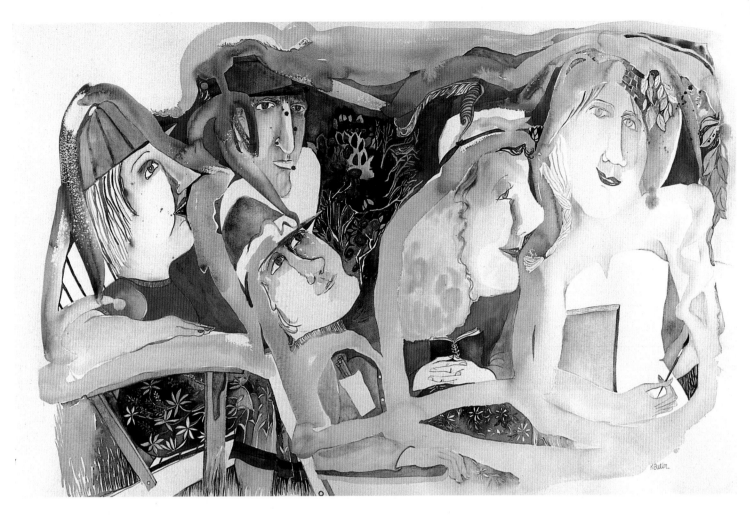

In my paintings, one of my goals is to show how people react to each other in the environment around them. I strongly believe that humans have an emotional connection to nature, one that is often forgotten in our modern world. When I look at the faces in *Absorbing Monhegan*, I see delight, serenity, happiness, tranquility, and the relief one feels in getting away from it all.

Karen Brussat Butler
Absorbing Monhegan

25" x 41" (64 cm x 104 cm)
Arches Double Elephant 260 lb. cold press

facing page

The challenge for me in painting these flowers was to use the brush as a drawing tool with no preliminary pencil drawing on the paper. To design as you paint is a challenging experience.

Eric Wiegardt
Roses

30" x 22" (76 cm x 56 cm)
Arches 300 lb. cold press

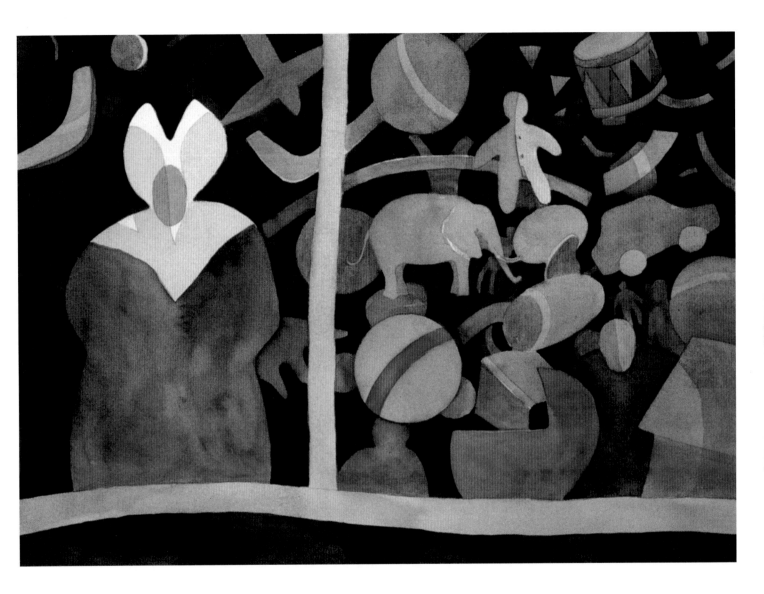

The study for this painting had abstract areas of color, but when I started the actual painting, I turned them into toys. There was something about the austerity of Sister Sarah's stance that made it seem as if she was reflecting bittersweetly on the children she herself didn't have and the children she had taught and loved.

Marjean Willett
Sister Sarah's World

22" x 30" (56 cm x 76 cm)
Arches 300 lb. cold press

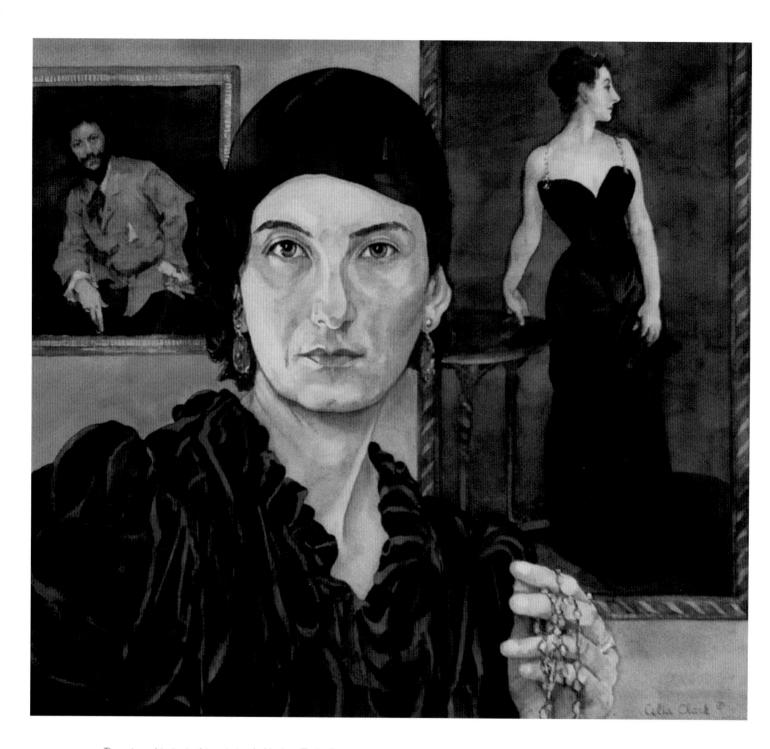

There is ambiguity in this painting. Is Madam Z aloof,
vulnerable, or guarded? I prefer that the viewer speculate.

Celia Clark
Madam Z

27" x 29.25" (69 cm x 74.5 cm)
Arches 140 lb. cold press

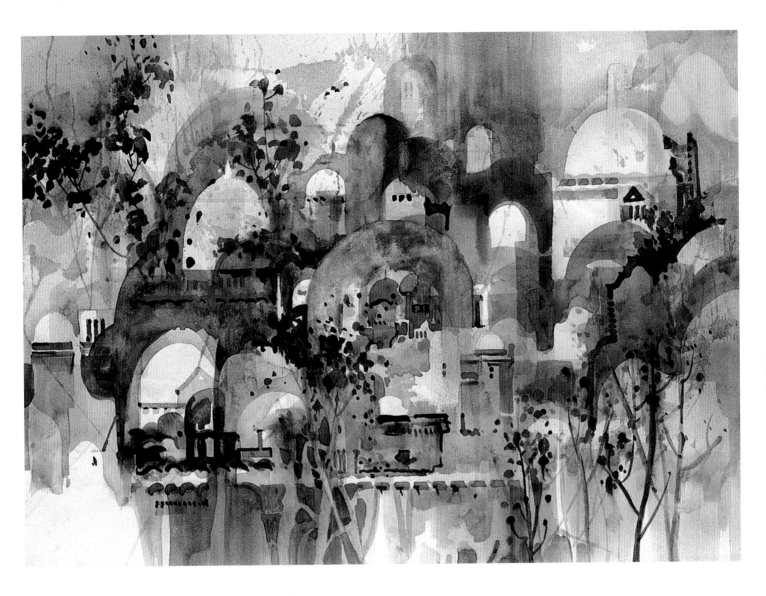

Faraway places spark the imagination, and there is a romance to the beauty of European architecture. As an architect trained in Chinese brush techniques, I use my watercolors as the alphabet of a new language that expresses admiration for these places.

Hal Lambert
A Place in Time

22" × 30" (56 cm × 76 cm)
Bockingford 140 lb. cold press

This painting expresses the feeling of elation when one has an expansive sense of self.

Howard Kaye
Whistlering in the Dark

21" x 29" (53 cm x 74 cm)
Arches 140 lb. cold press

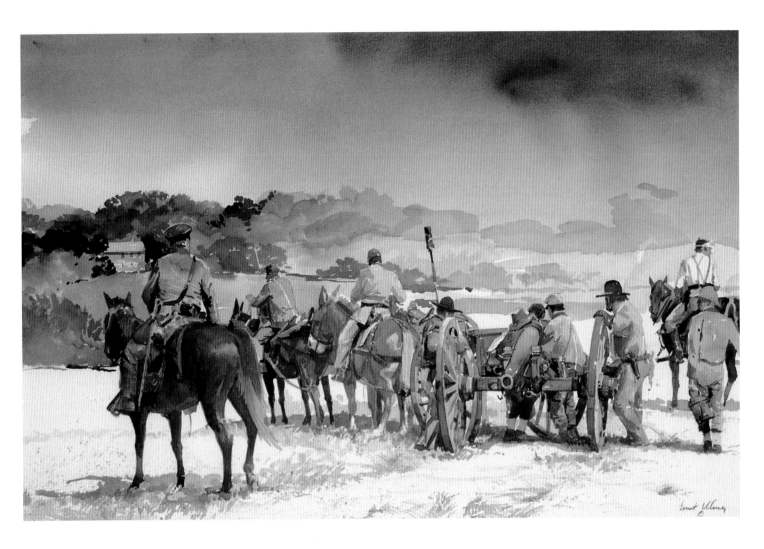

There are many Civil War reenactments in Kansas, where I live.
Rebs Moving a Gun is a scene from one of these reenactments.
It depicts the soldiers repositioning their guns after an exchange
of gunfire. There is a lot of excitement and tension.

Ernst Ulmer
Rebs Moving a Gun

17" x 26" (43 cm x 66 cm)
Crescent watercolor board, Strathmore surface cold press

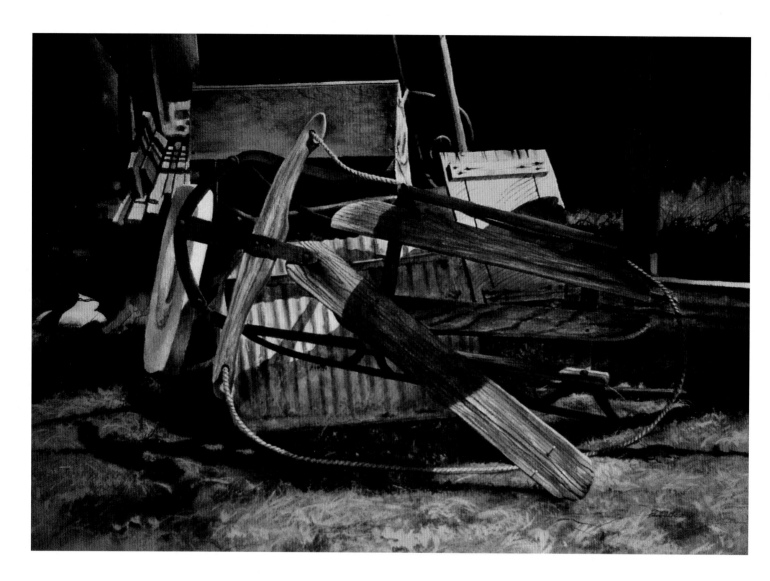

The broken, discarded sled in this painting recalls a happier
time, when it brought much joy to a lucky youngster.

Richard Brzozowski
Junk Pile

18" x 24" (46 cm x 61 cm)
Arches 140 lb.

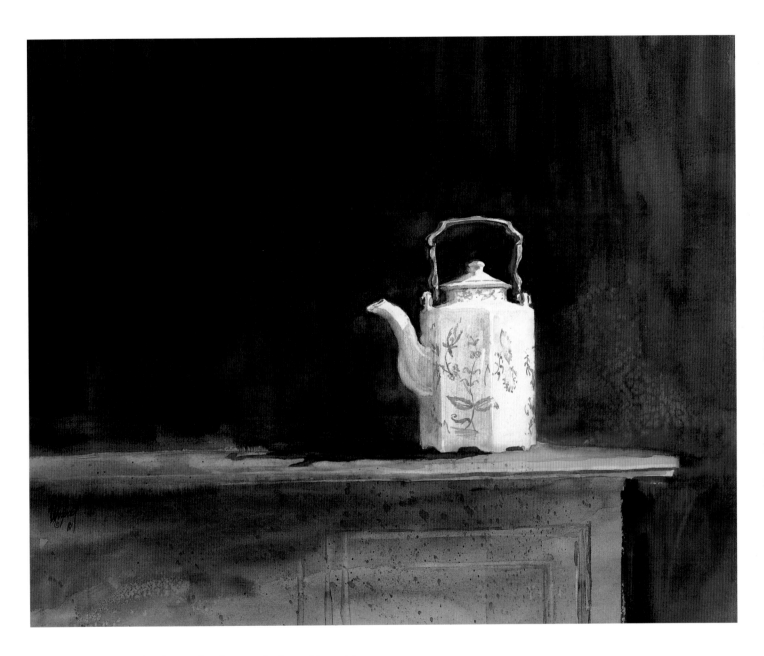

Like her beloved tea maker, Gran was fragile as old porcelain
yet sturdy. After her death, her tea maker stood atop a cabinet,
alone and forgotten. It seemed appropriate to capture this
lonely image against a stark background, simple and
unadorned, in a silent testament to someone special.

Nancy Wostrel
Gran's Tea Maker

13" x 17" (33 cm x 43 cm)
Fabriano 140 lb. cold press

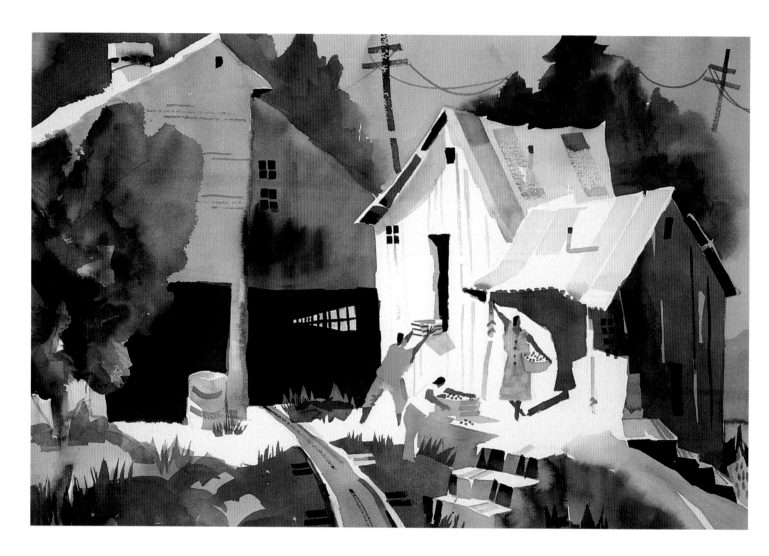

The impatient gesture of the woman in this painting evokes the
feeling of anticipation, and the deep, dark shadows around her
create a sense of isolation.

Ellen Negley
All Aboard

22" x 30" (56 cm x 76 cm)
Arches rough

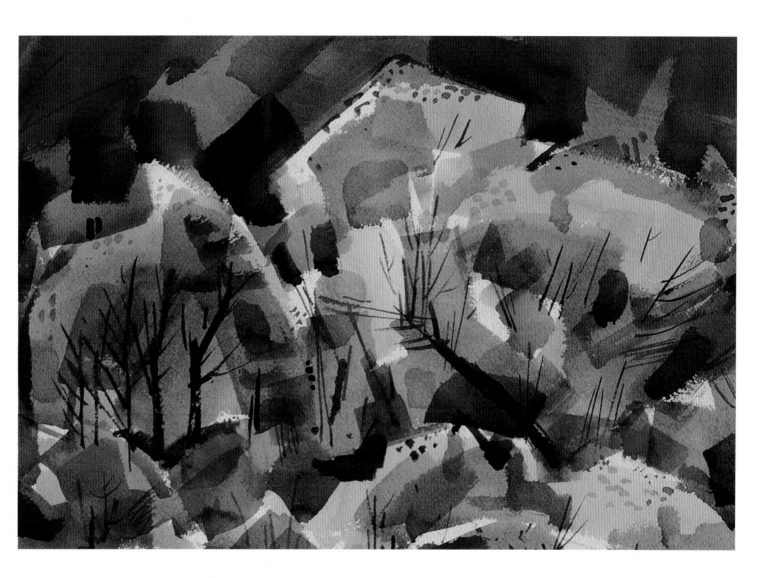

*This watercolor represents the pleasure of seeing this
unexpected fall scene in a desert canyon along Highway 33
near Ventura, California.*

John Barnard
Highway 33

14" x 20" (36 cm x 51 cm)
Arches 140 lb. rough

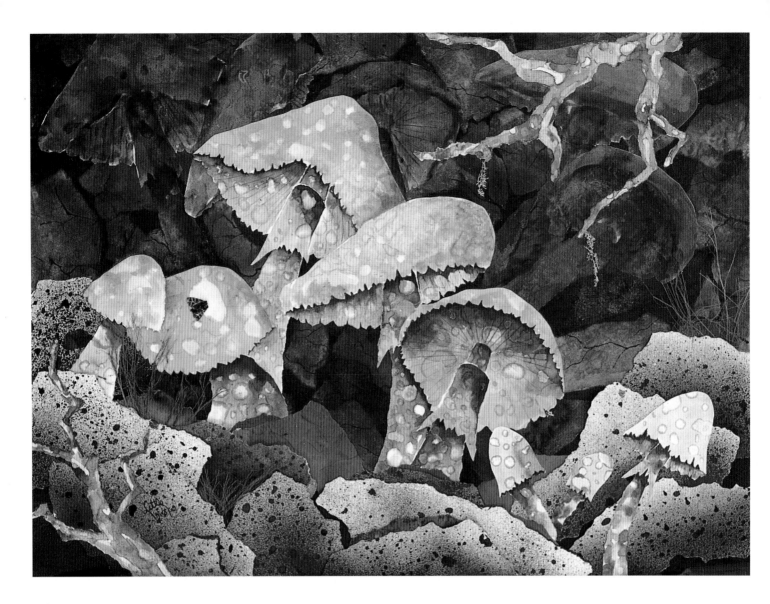

This painting is part of a series in which I wanted to evoke the sense of mystery and drama that one feels in a dark forest. But in this case, I wanted to create it in a whimsical manner. To accomplish this, I collaged several kinds of paper and used several mediums—watercolor, ink, and acrylic. In the end, I was able to create a wonderful weathered look that cannot be achieved with a paintbrush alone.

Jerry Little
Magical Forest VIII

22" x 30" (56 cm x 76 cm)
Arches 300 lb. cold press
Watercolor with drawing ink and acrylic

facing page

Lasting Impression is about the sweet aroma of a flower, the song of a bird, and the gold of a sunrise. It's about things that make all of us feel good. The bird represents the freedom to be me. The flower and buds represent future beginnings. I am always thankful to be an artist, as it makes me really enjoy the world around me. For me, this painting stirs that feeling of joy.

Phyllis Hellier
Lasting Impression

30" x 22" (76 cm x 56 cm)
Arches 300 lb. cold press
Watercolor with gouache and ink

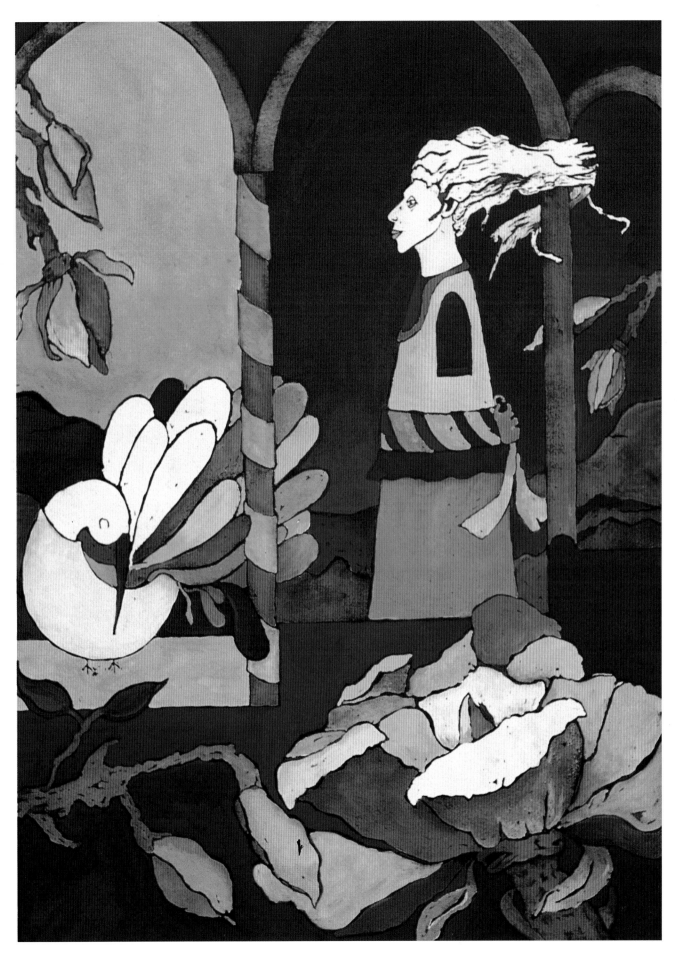

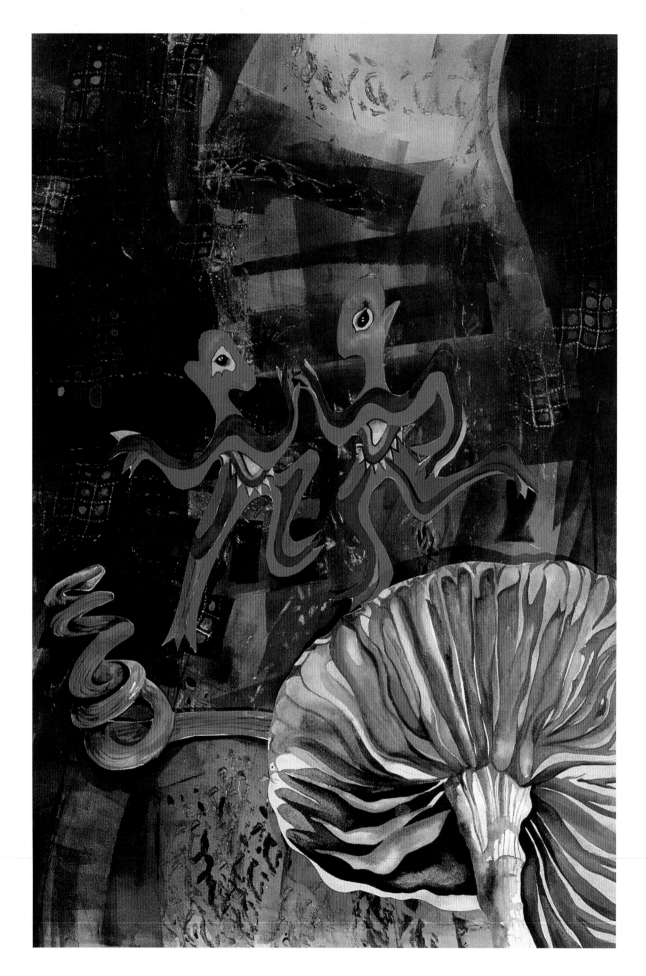

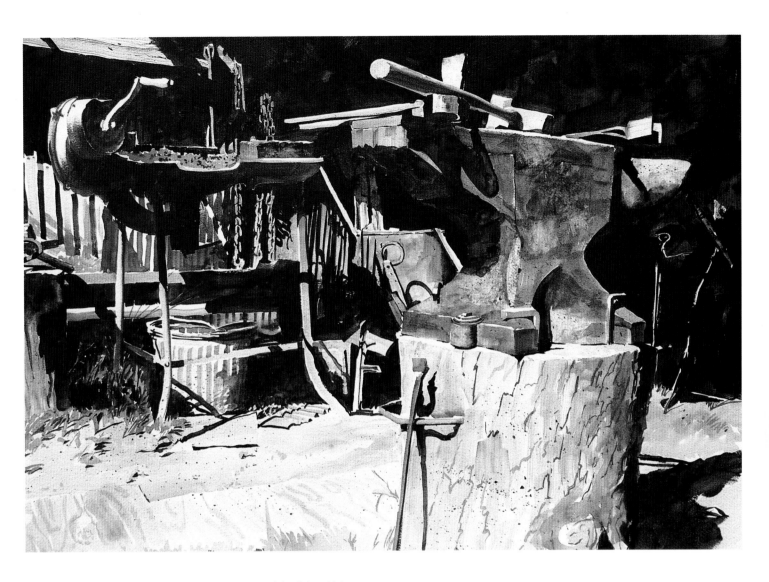

It was a cold day in May when I painted Anvil. I couldn't get over the feeling of warmth the sun gave the anvil and surrounding tools and wood—it was very comforting and warm.

Robert Sakson
Anvil

22" x 30" (56 cm x 76 cm)
Arches 140 lb. rough

facing page

Here, the two figures are taking steps to preserve the rainforest —it's an act of faith. The helix curve represents the hope of preserving DNA elements. The mushroom represents the sphere—the balance between inward and outward forces. The color field behind the figures represents life as a continuous journey of mysteries.

Ellna Goodrum
Rain Forest

36" x 28" (91 cm x 71 cm)
Arches 140 lb. cold press
Watercolor and collage

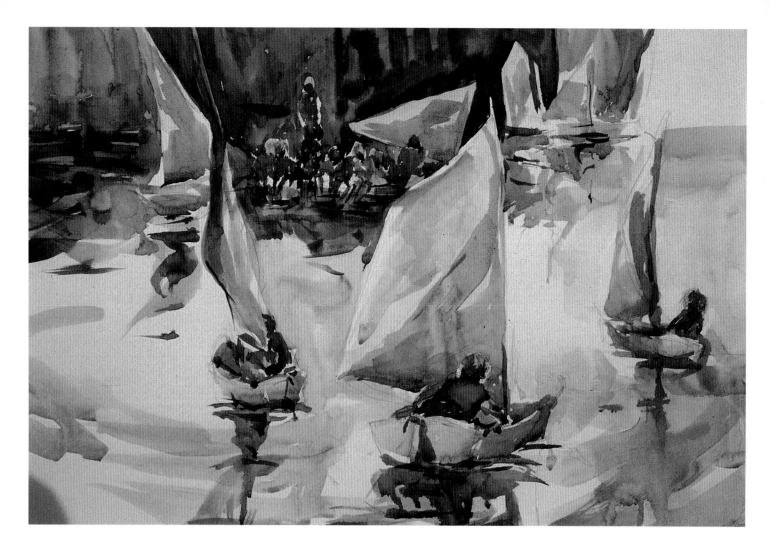

This painting depicts the joy and playfulness of the sails
responding to the wind. Like the movement of the sails, my
brushstrokes were alternately spontaneous and deliberate.

Lori E. Hayes
Sailing Lessons

14.5" x 21.5" (37 cm x 55 cm)
Fabriano 140 lb. hot press

facing page

*The gallery where I rent studio space was empty for a month,
and this chair was left over from a drawing class. A piece
hanging from a previous show blocked the light, so that it came
over and around the chair. Something about the warmth of the
chair against the coldness of the wall intrigued me. It seemed to
speak of emptiness, but also hope and waiting.*

Suzy Schultz
Chair

29" x 21.5" (74 cm x 55 cm)
Lanaquarelle 140 lb. hot press

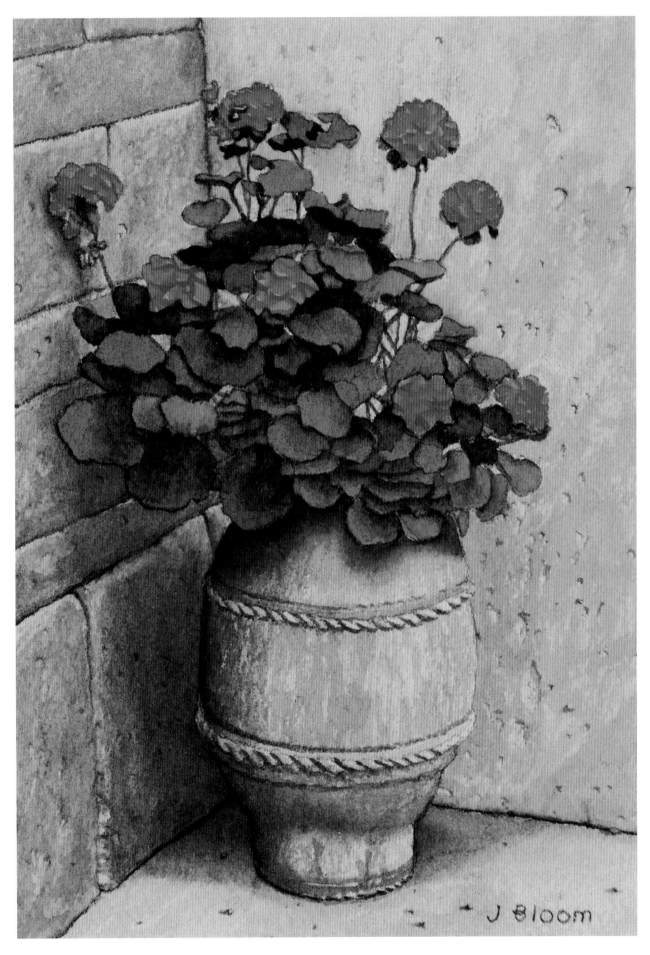

91

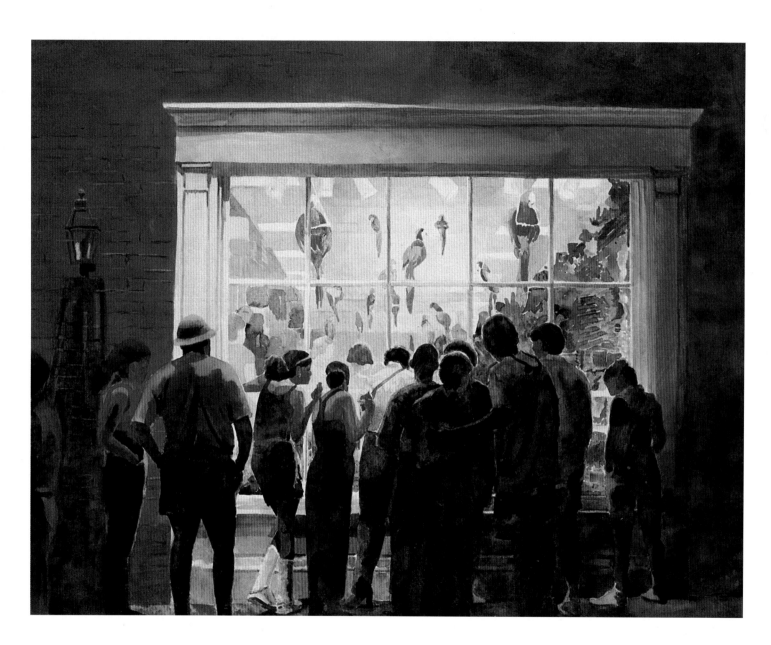

In Parrot Shop, *the window separates the world on the inside from the world on the outside—and it frames the passersby who stopped to enjoy one of life's satisfying moments. I used the metaphor of the window to change the temperature of the light and silhouette the onlookers. Clear, cool transparent colors depict the fluorescent glow from inside the shop. For the brick wall, I switched to warm, dark values to express the ambience of a summer evening illuminated by streetlights. This approach provided the "shining from within" drama I was after.*

Mariya K. Zvonkovich
Parrot Shop

14" x 19" (36 cm x 48 cm)
300 lb. with a thin coat of gesso
Watercolor with gouache

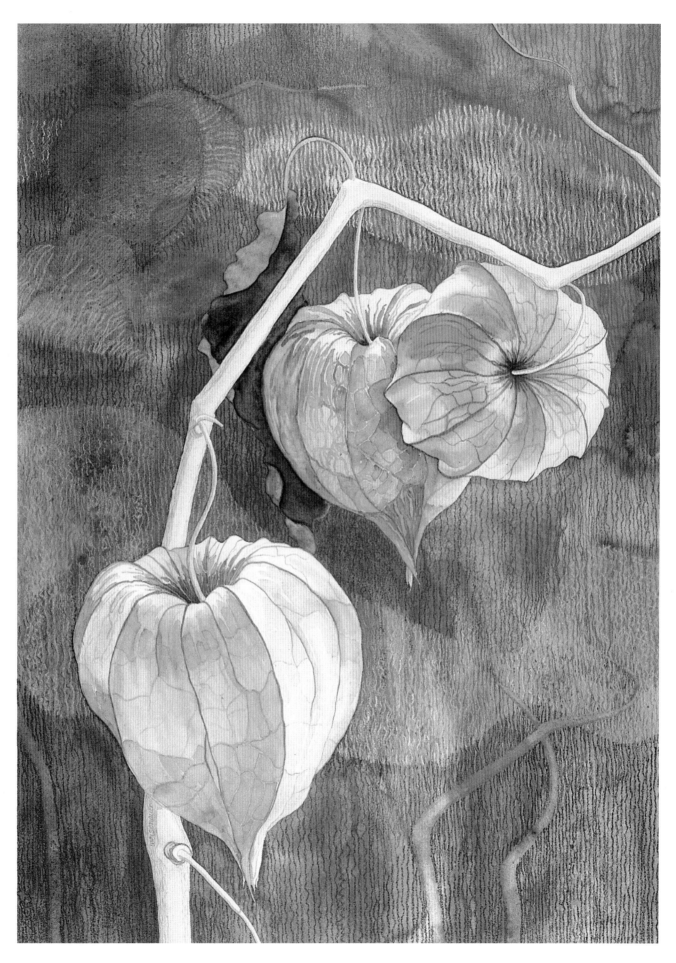

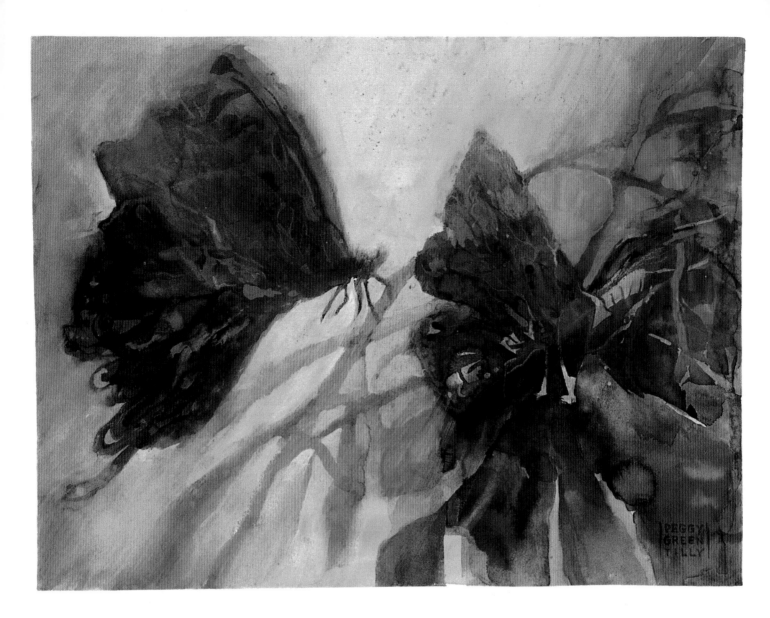

'This was not a preconceived painting. I randomly applied colors and allowed them to mix and dry. Several weeks later, I began to see the possibility of butterfly wings, so I carefully painted negatively and opaquely around my subject with pale color. Butterflies have always given me a jolt of joy whenever I have glimpsed their colorful flight. They have such beautifully fragile wings. Creating this painting affected me the same way. It was a quick, joyful happening.

Peggy Green Tilly
Gossamer Gathering

30" x 22" (76 cm x 56 cm)
Arches 140 lb. cold press
Watercolor with acrylic

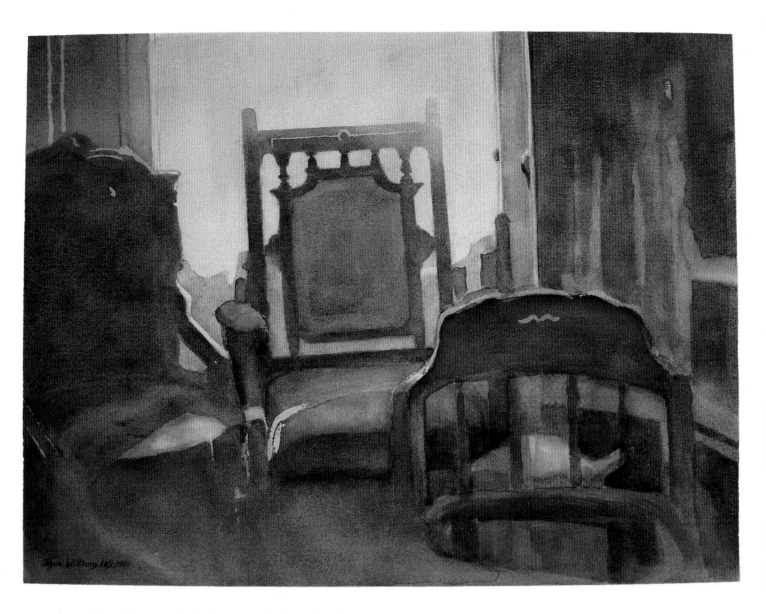

Three Chairs *was inspired by a room in a house close to my own home. The light from the window shows decay but also symbolizes hope.*

Joyce Williams
Three Chairs

22" x 30" (56 cm x 76 cm)
Arches 300 lb. cold press

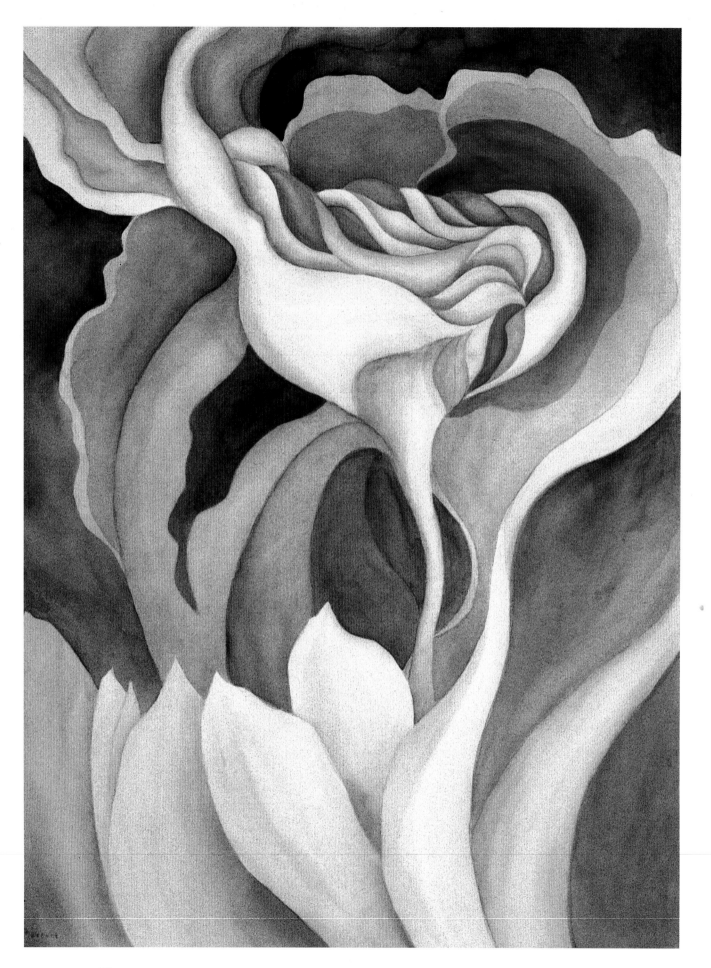

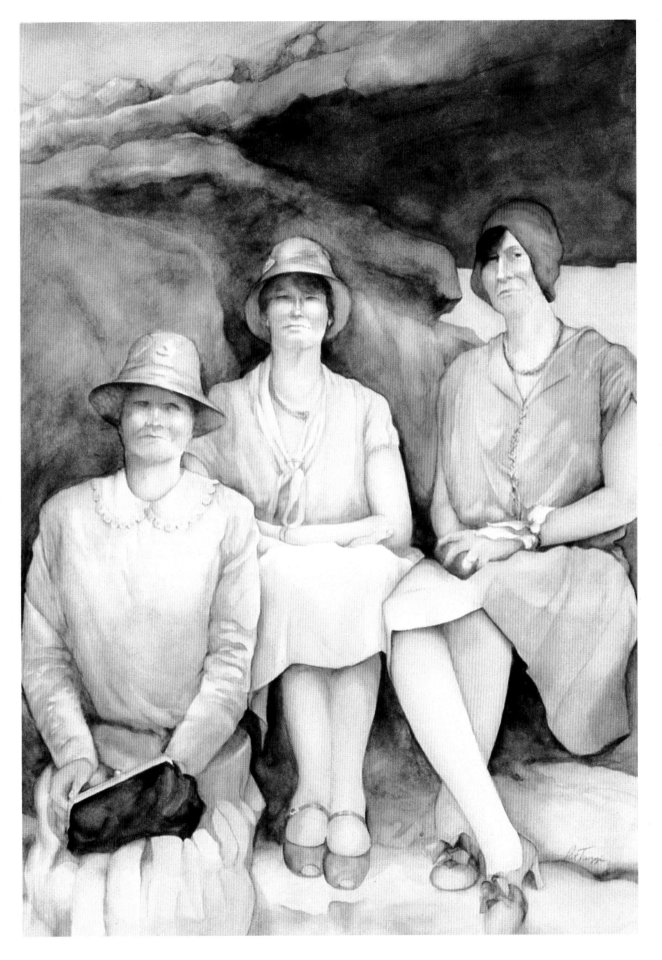

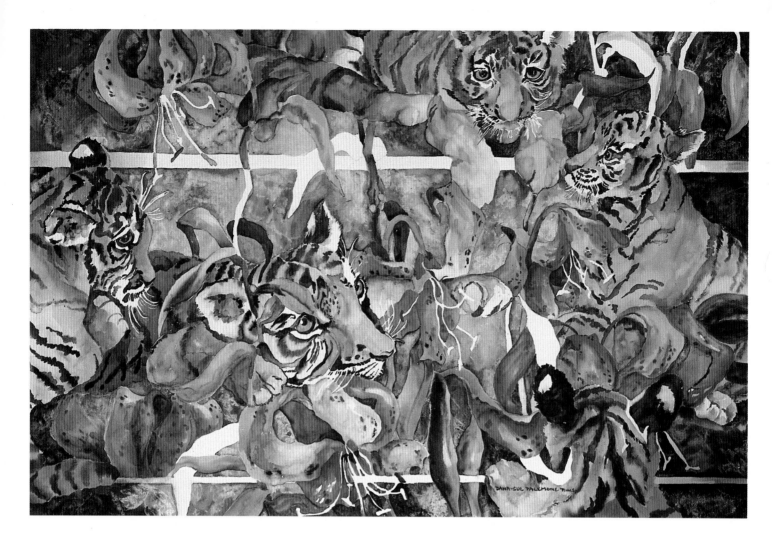

These precious newborn tiger cubs and the tiger lilies are
representative of all the growing things that make life so
beautiful. They are also representative of the cycle of life
renewed. Tiger lilies are my favorite flowers—my grandmother
had them in her front yard.

Dana-Sue Palemone
Tiger Lilies

22" x 30" (56 cm x 76 cm)
Arches 300 lb.

facing page

I wanted to convey the joy of realizing that humanity is con-
nected to nature—all roots connect and interact, providing an
eternal home base.

Dee Gaylord
Connected

37" x 29" (94 cm x 74 cm)
Arches 180 lb.

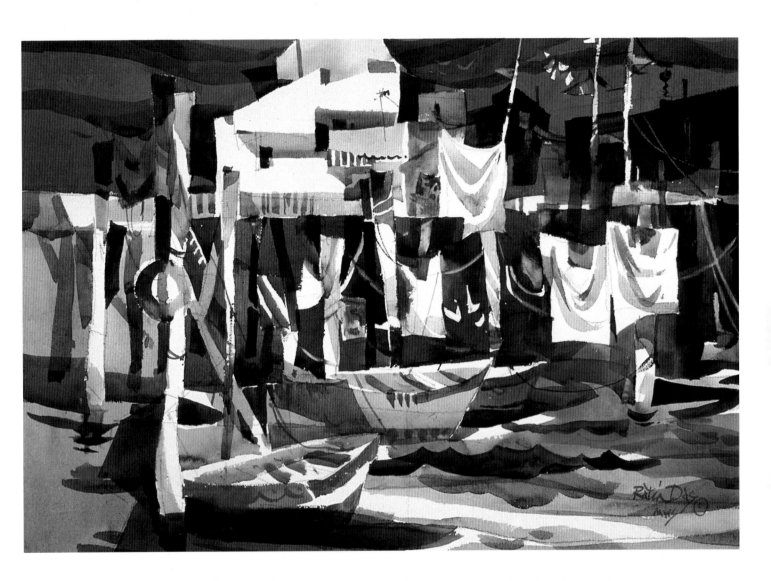

The Blue Wharf *is an intuitive painting based on many memories of the interesting shapes—clotheslines, signs, miscellaneous hangings, decorative posts, banners, etc.—that are usually present in a tourist destination like Fisherman's Wharf at Monterey Bay, California. This subject matter has been used in paintings hundreds of times, but I still like the excitement of the place and wanted to give it a little twist by exaggerating it. The idea was to convey happiness, excitement, and the sense of a place that is full of fun and, perhaps, nostalgia.*

Ratindra K. Das
The Blue Wharf

20" x 30" (51 cm x 76 cm)
Approximately 140 lb. handmade Indian paper

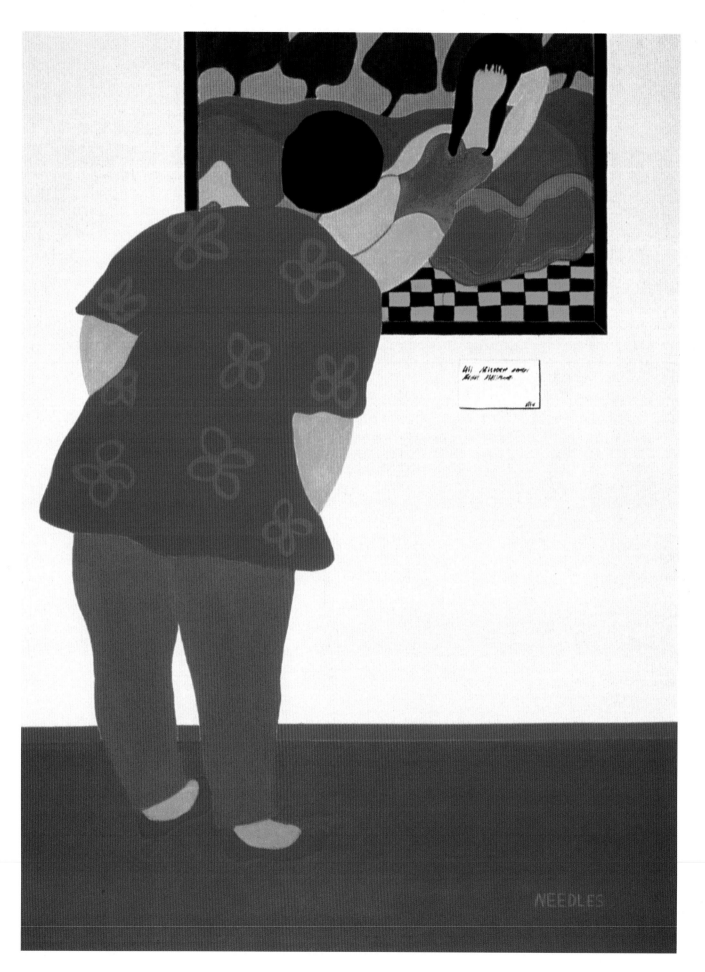

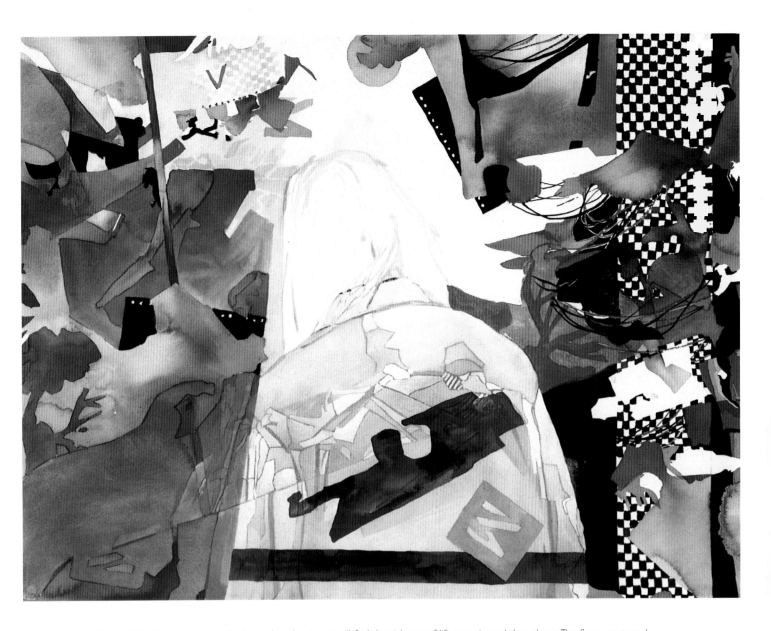

The Artist's World *presents the hope that the viewer will feel the richness of life experienced through art. The figure portrayed is the artist facing her painting. The viewer is invited to see as the artist and experience the joy of creation. This feeling is communicated by the use of stencils to enclose fluid interminglings of color juxtaposed on the white paper.*

Marilynn Derwenskus
The Artist's World

22" x 30" (56 cm x 76 cm)
Fabriano 140 lb. rough

facing page

In this painting, I was trying to convey a fleeting moment that everyone can relate to. I also like to playfully exaggerate the figure, for extra interest and drama. I applied many layers of acrylic and gouache for richness and depth.

Helen Needles
How Did She Do That?

40" x 30" (102 cm x 76 cm)
Crescent 115 lb. hot press
Watercolor with acrylic, gouache, and gesso

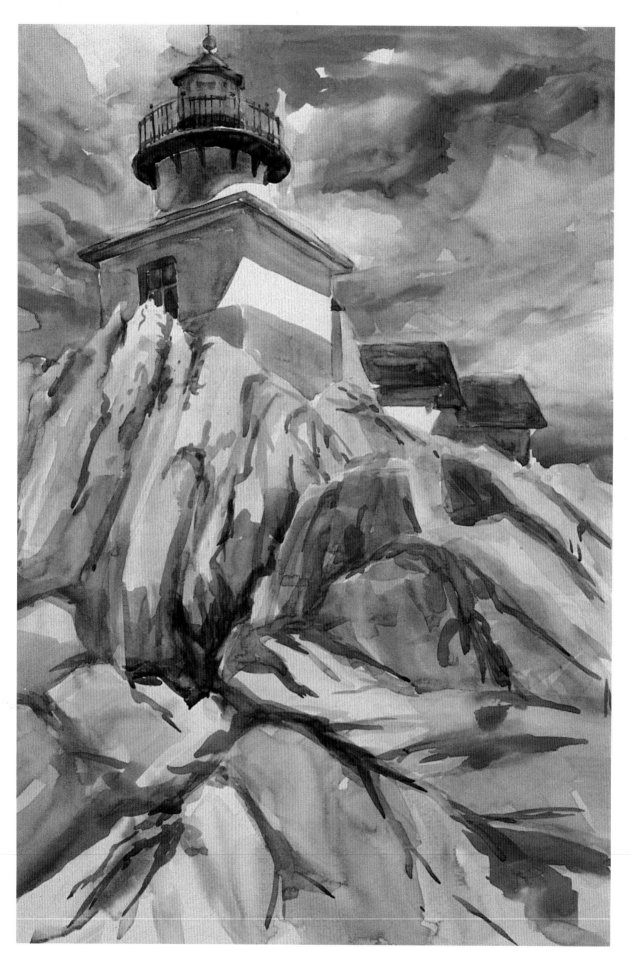

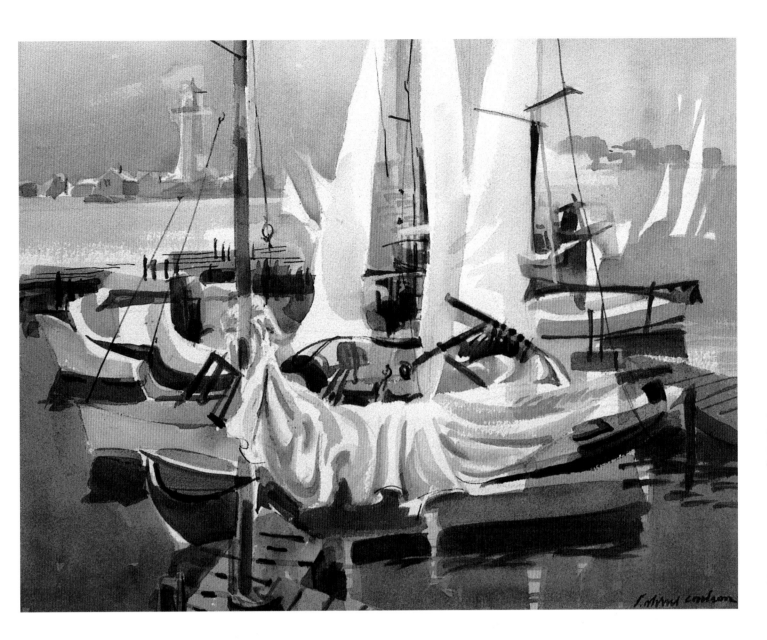

With this painting, I wanted to portray the beauty of the
summer sailboats in Sandy Bay, Massachusetts.

Sven Ohrvel Carlson
Summer Sails

16" x 24" (41 cm x 61 cm)
Arches 140 lb. cold press
Transparent watercolor

facing page

This painting was a challenge. I had to climb to the bottom of
these rocks in Gloucester, Massachusetts, with my French sketch
easel to capture the feeling of strength that the lighthouse
conveyed.

Reneé Emanuel
Eastern Point Light

32" x 26" (81 cm x 66 cm)
Strathmore Imperial 140 lb. cold press

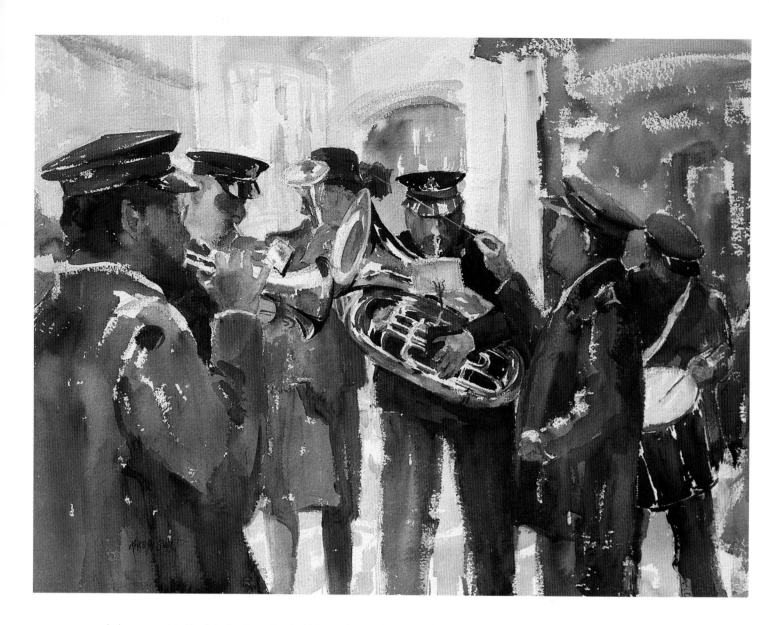

I always associate the Salvation Army Band with happy, joyous times, something I tried to convey in this painting. I saw this band in Bath, England, made some on-location sketches, and took several photographs, which provided enough source material for a studio painting when I returned to the United States.

Marilyn Swift
Salvation Army Band

21" x 28.5" (53 cm x 72 cm)
Arches 300 lb. rough

facing page

Across the river from Fort Leavenworth is Weston, Missouri, a river town of historic importance. Shown is a typical tourist husband waiting for his wife; a town local has found a willing ear. I was impressed by this humorous scene. One of the men was more than likely retired, and the other has little to retire from.

Ernst Ulmer
Morning Politics

15" x 13" (38 cm x 33 cm)
Crescent watercolor board,
Strathmore surface cold press

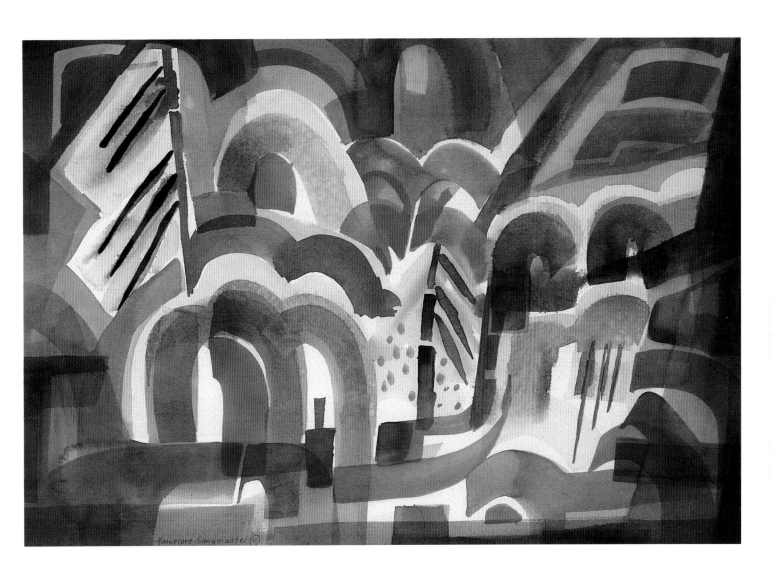

My favorite place on this earth is Yosemite National Park in
California, where we have spent many vacations and where
I have painted several scenes in a representational style.
Vacation Spot is strictly meant to express my innermost
feelings for the atmosphere and charm of the area, where sun,
air, mountains, and trees come together in spiritual unity.

Hannelore Sangmaster
Vacation Spot

22" x 30" (56 cm x 76 cm)
Arches 140 lb.

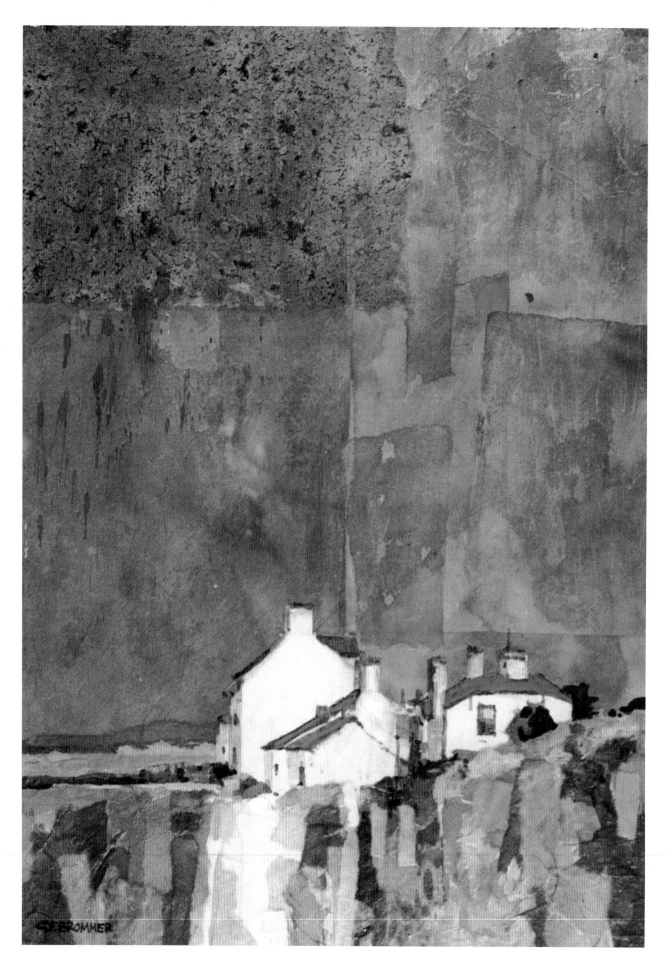

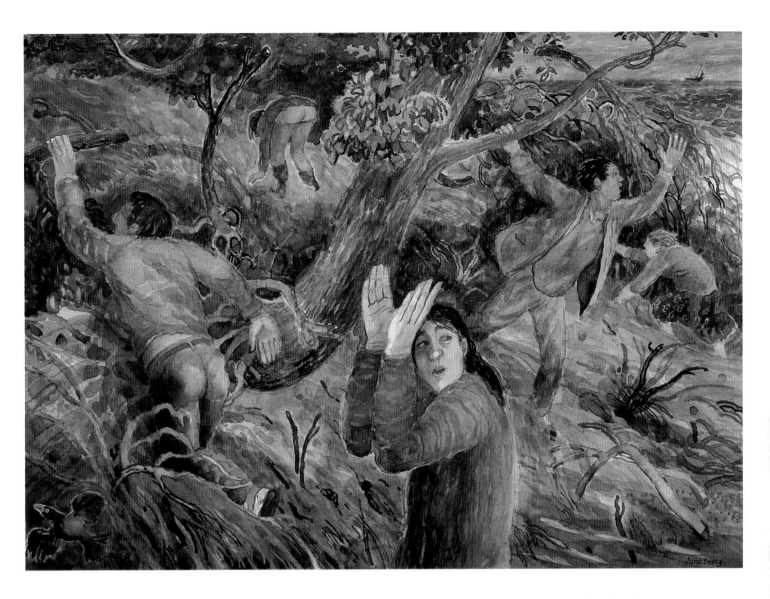

This painting is an expression of the fear, or even terror, felt by those who have been exposed to violent natural forces. The repeating diagonals give a restlessness to the composition, and the somber colors built up with layers of transparent watercolor add to the dark and stormy mood.

June Berry
Storm in the Estuary

20" x 28" (51 cm x 71 cm)
260 lb. paper

facing page

The subject is the small town of St. Just in England's West Country. I wanted to convey the solidity and perseverance this town has had in the face of storms and hard times. Anything that survives in this part of England is tough!

Gerald F. Brommer
View of St. Just

15" x 11" (38 cm x 28 cm)
Arches 300 lb. rough
Watercolor, collage, and gouache

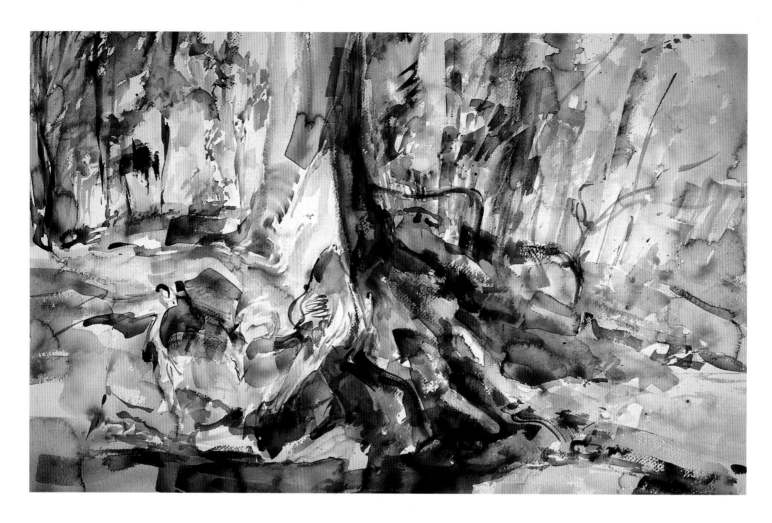

In the fall, there is joy over the explosion of color but also sadness over the fact that the leaves are dying and will be gone for another half year.

Alex McKibbin
Environs of Pamajera

29" x 40" (74 cm x 102 cm)
Arches 550 lb.

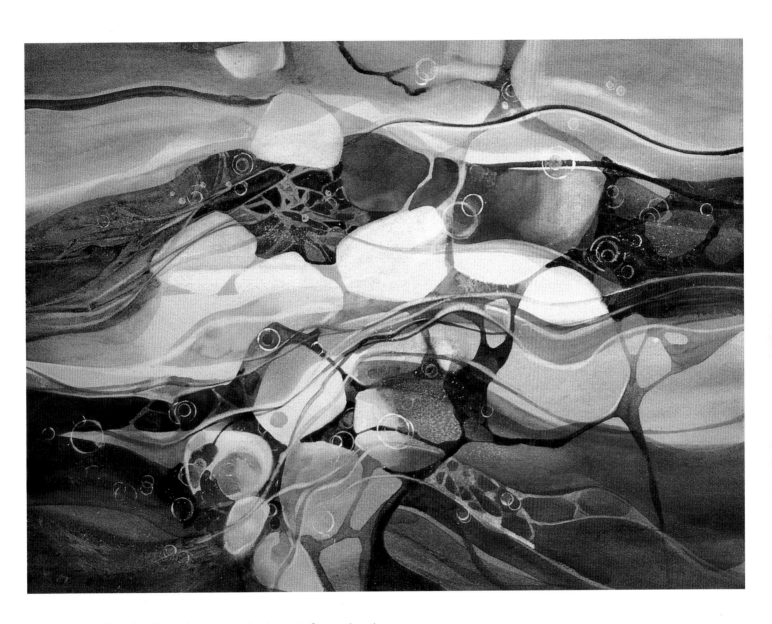

Memories of natural phenomena inspire most of my work, and this painting is no exception. Seven miles from my door lies the Pacific Ocean, with its beautiful lagoons and inlets. Without belaboring realism, I brought this painting to a simplified and fully realized watercolor. The transparent flowing water opens the heart to truth and joy.

Marge McClure
Lazy Current

20" x 26" (51 cm x 66 cm)
Arches 140 lb. cold press
Watercolor with some opaque white

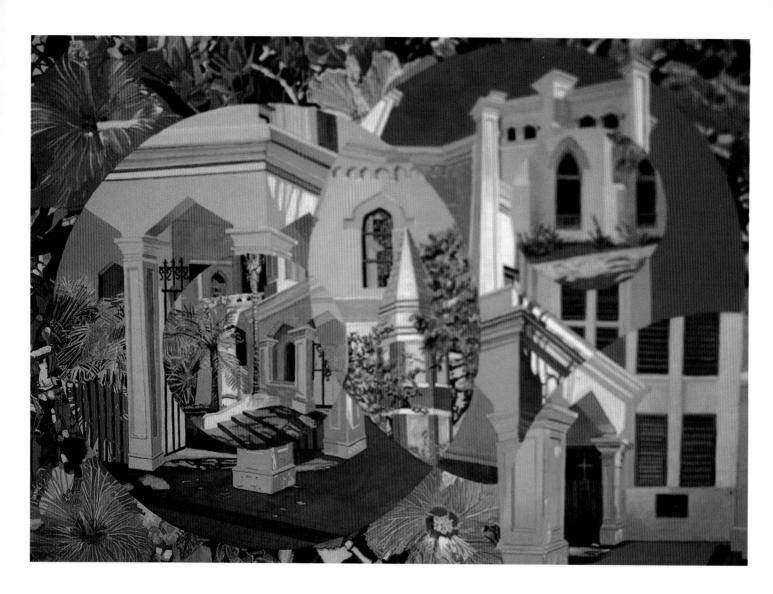

*My first architectural subject came about while in Key West,
where the partial views of lovely old buildings suggested a larger
perspective.*

Electra Stamelos
Flower Series—Key West

22" x 30" (56 cm x 76 cm)
English paper
Watercolor with Chinese white

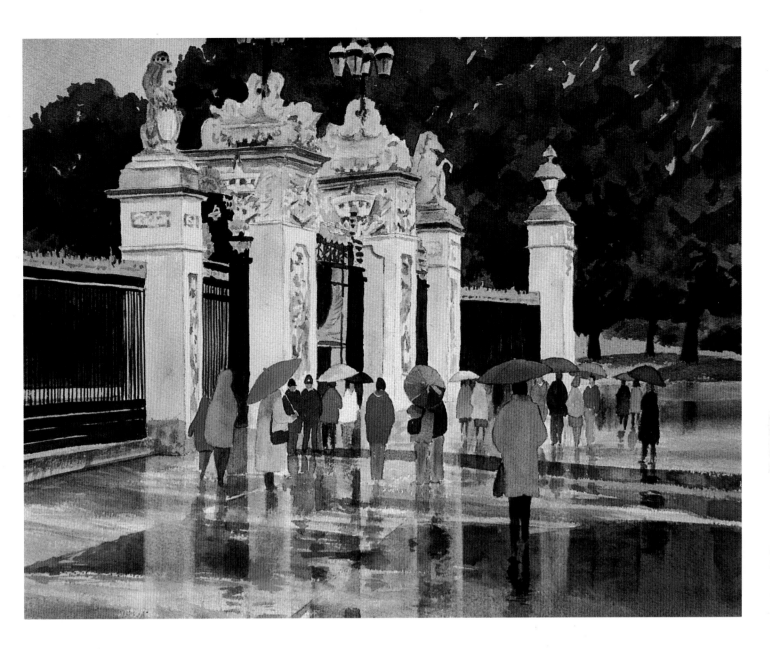

Seeing the massive gates of Buckingham Palace one rainy afternoon recalled the historic power of the monarchy. I contrasted the strong verticals of the gates with the people to express this feeling of vulnerable strength.

John Salchak
Palace Gate

14" x 18" (36 cm x 46 cm)
Arches 140 lb. rough

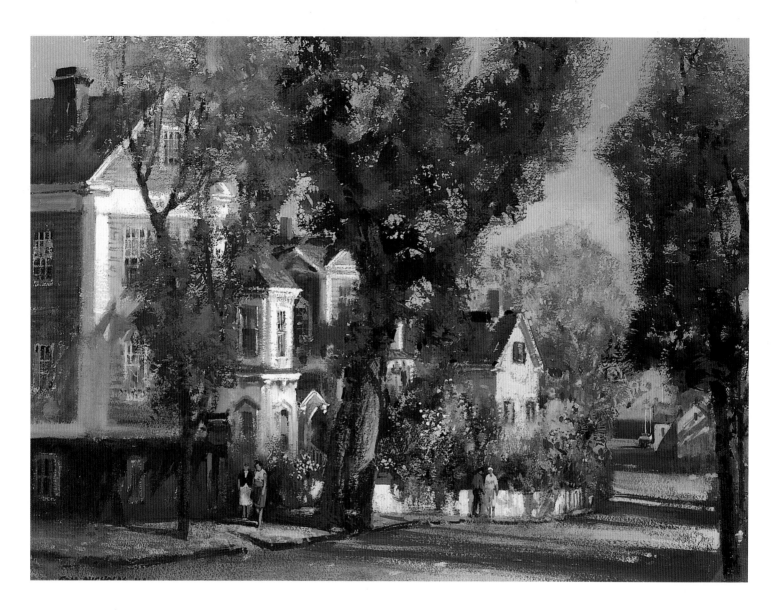

*Spring is a joyful time of year, and nature's rebirth is especially
beautiful on Nantucket Island, with its majestic old elm trees. I
wanted to express the poetry and charm of this special season.*

Thomas Nicholas
Spring, Nantucket

21" x 29" (53 cm x 74 cm)
Arches 400 lb. cold press

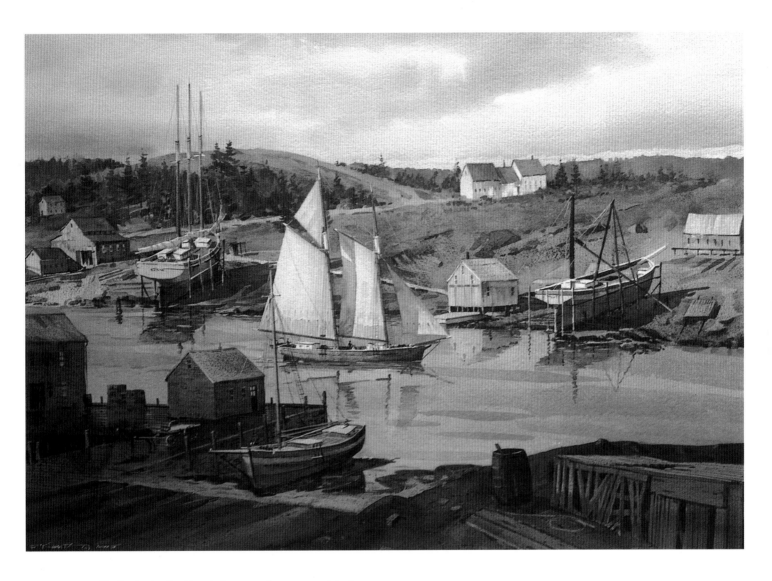

The inspiration for this painting came from my nostalgia for a slower-paced, simpler life. I had seen some old photographs of the area at the Maritime Museum in Searsport, Maine. What caught my eye was the activity captured on a warm, quiet summer day. The shipbuilding activities in the background and the sparsely settled land behind it give the viewer a feeling of being there.

Frederick Kubitz
Shipbuilding along the Penobscot River c.1900

22" x 30" (56 cm x 76 cm)
Arches 300 lb. cold press

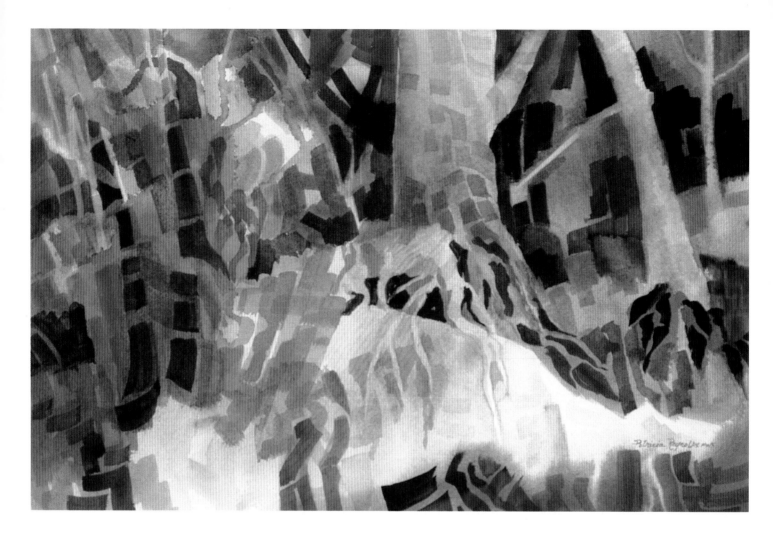

Living in Adirondack Park, I spend a lot of time in the woods. My memories of the forest inspire my paintings, and I am constantly trying to interpret it in different ways. In this case, I was going for a dark, mysterious feeling.

Patricia Reynolds
Forest Mosaic

14" x 21" (36 cm x 53 cm)
Arches 140 lb. cold press

facing page

My paintings tell personal stories. To add drama, I arrange my objects as if I were setting a stage. I hope that the dialogue between the viewer and my work is a mixture of mystery and curiosity.

Shirley Zampelli Sturz-Davis
Frog Angel of Griffin Chair Land

28" x 20" (71 cm x 51 cm)
Arches 300 lb.

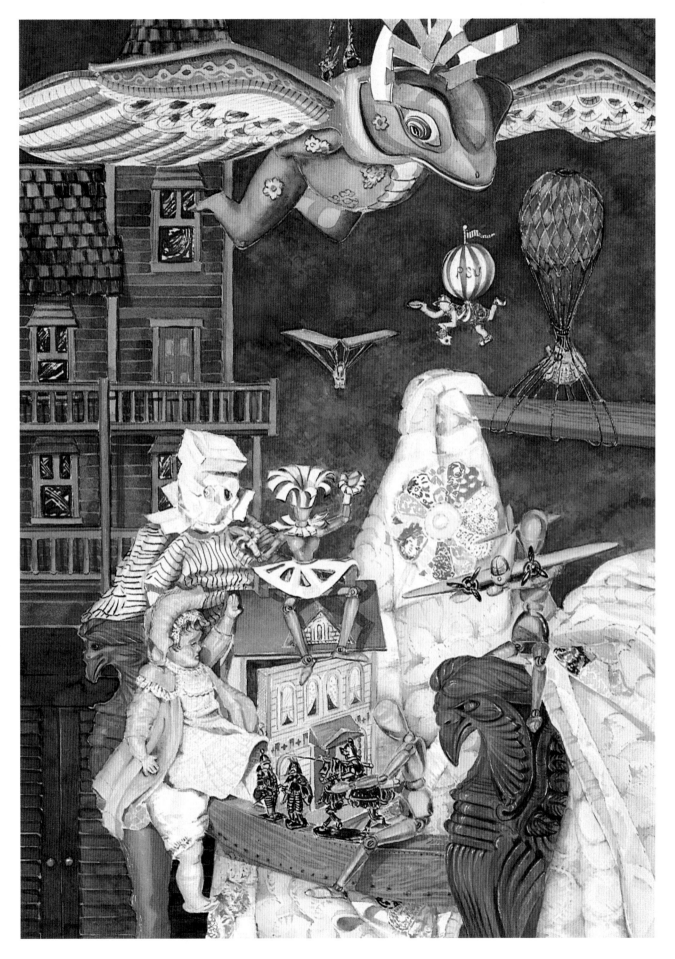

Many people tell me I make happy paintings. That's probably because I seek to attract the viewer through design and color. Almost all of my paintings contain red, for example. And I always compose in a way that's pleasing to the eye as opposed to creating a composition that defies it.

Sandra E. Beebe
Palette with Lava

22" x 30" (56 cm x 76 cm)
Arches 140 lb. cold press

facing page

This painting represents the pensive, melancholy feelings that are evoked in the music of the blues.

Donne Bitner
The Blues

30" x 22" (76 cm x 56 cm)
Aquarius II 90 lb.
Watercolor with fluid acrylic

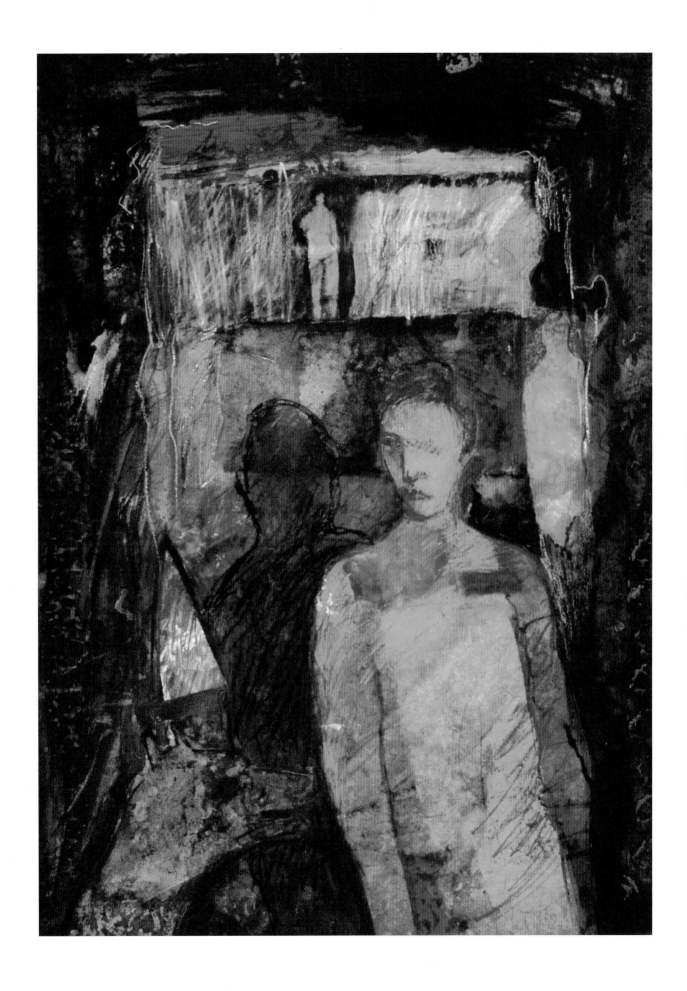

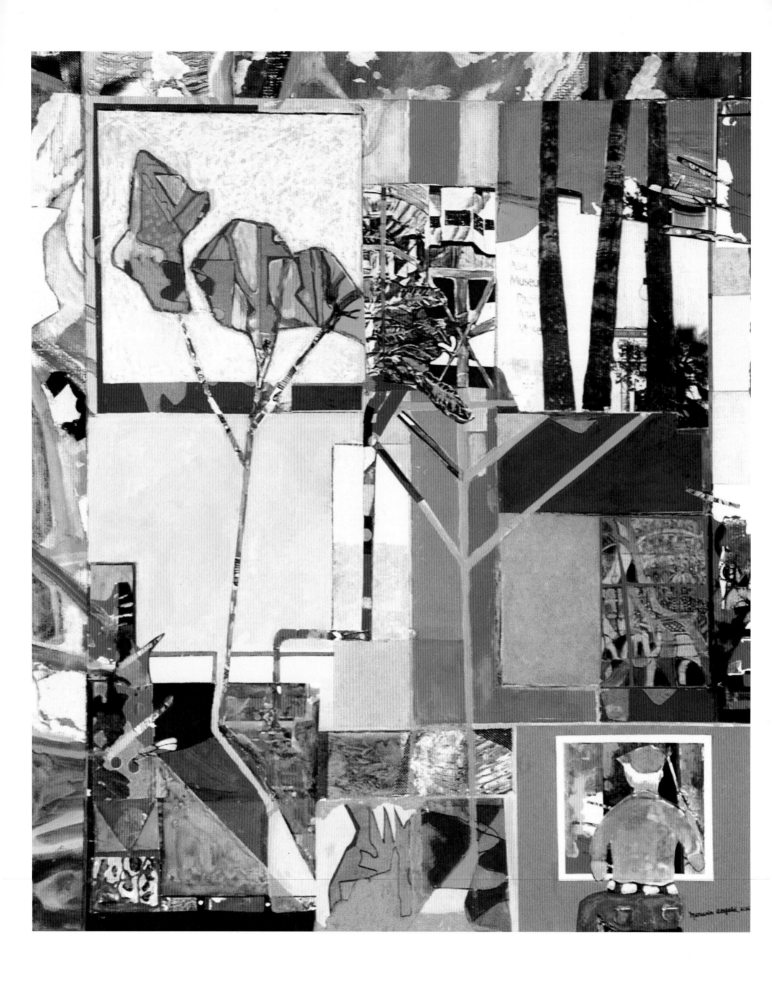

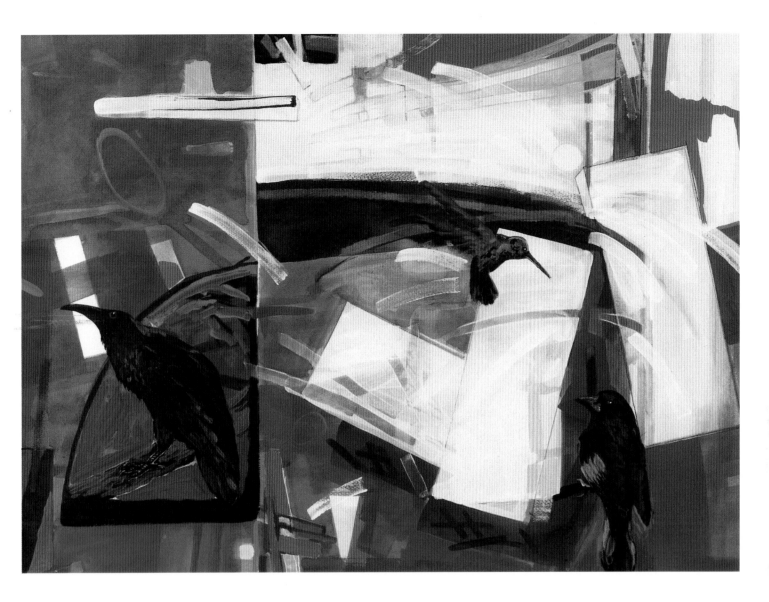

Birds are a recurring motif in my work. I was inspired to paint
Jungle Jangle *after watching in helpless dismay as a crow
landed noisily on our deck railing with a robin's egg spilling from
its beak. I had been "protecting" that particular nest.*

Mary Britten Lynch
Jungle Jangle

26" x 32" (66 cm x 81 cm)
Arches 140 lb. cold press
Watercolor with Chroma Colour

facing page

*This brilliant California day demanded vivid colors. I used varied
geometric shapes of solid color to express joy and playfulness. I
felt so much a part of this painting that I put myself into it.*

Merwin Altfeld
View Point

30" x 25" (76 cm x 64 cm)
Crescent/Strathmore 300 lb.
Watercolor with acrylic

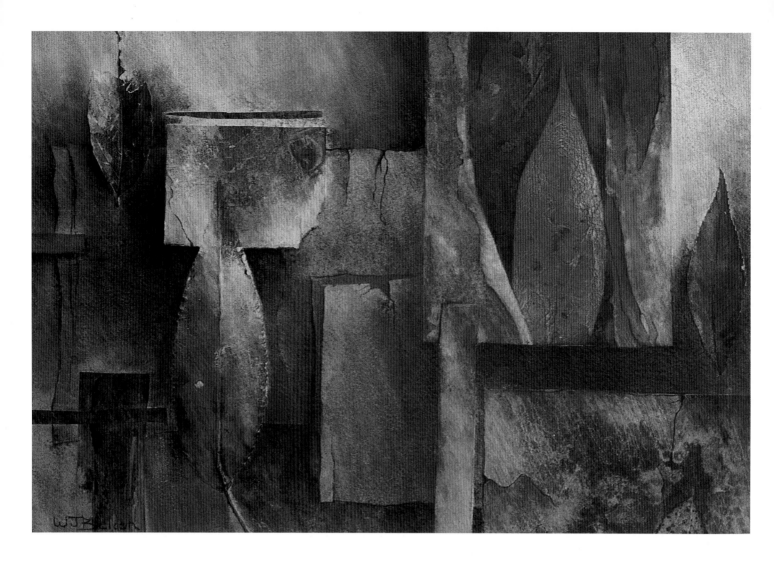

For me, leaves and trees are icons representing our spiritual connection with nature. In my paintings, I try to paint my feeling of joy for this wonderul bond.

Willena J. Belden
Evolution

9'' x 13.5'' (23 cm x 34 cm)
Arches 140 lb. cold press
Watercolor with inks and acrylic

facing page

This painting was inspired by a visit to Antibes, where Picasso once lived. I imagined what it would be like to spend my life painting and frolicking by the sea as he did. I really wanted to try to get inside Picasso's head.

Betty Braig
Picasso/Antibes

40'' x 30'' (102 cm x 76 cm)
BFK Rives medium-weight paper
Watercolor with acrylic and gouache

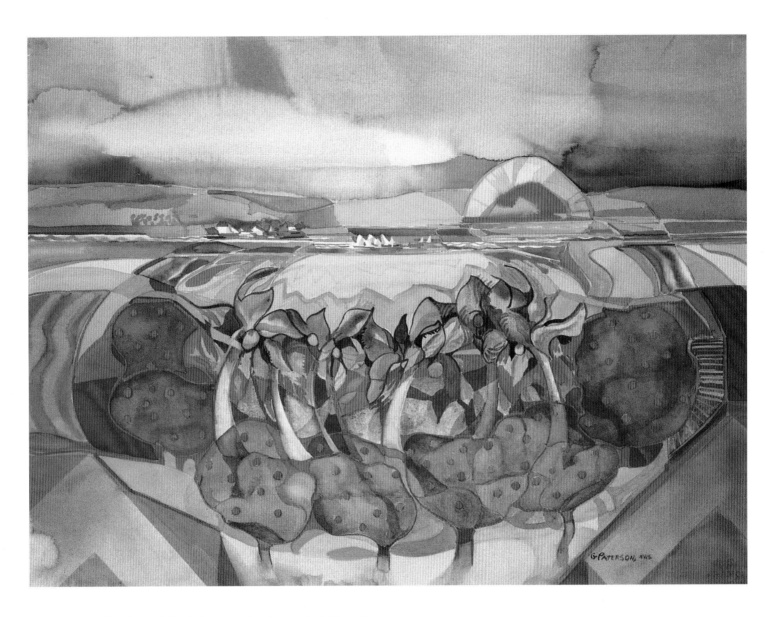

The Orange Belt's abstracted, designed landscapes are meant to elicit a feeling of pleasure. Stylized palm trees surrounded by orange trees fill the foreground, while the aerial view leads the eye to a diminishing horizon. The cool values of the distance, suggesting early day, gradually turn to a blush rose, indicating the passage of time and suggesting an early sunset, which is frequently quite beautiful.

Gloria Paterson
The Orange Belt IV

22" x 30" (56 cm x 76 cm)
Arches 300 lb. cold press

DIRECTORY

Merwin Altfeld 128
18426 Wakecrest Drive
Malibu, CA 90265

John Barnard 81
8790 Monita Road
Atascadero, CA 93422

Robert L. Barnum 55
9739 Calgary Drive
Stanwood, MI 49346

Judy Bates 37
2165 Laurel Woods Drive
Salem, WA 24153

Sandra E. Beebe 126
7241 Marina Pacific Drive South
Long Beach, CA 90803

Willena J. Belden 130
2059 Rambler Road
Lexington, KY 40503

Lorna Berlin 53
59 Catherine Street
Williamsville, NY 14221

June Berry 117
45 Chancery Lane
Beckenham, Kent BR3 6NR
U.K.

Donne Bitner 127
449 Blakey Boulevard
Cocoa Beach, FL 32931

Julian Bloom 91
4522 Cathy Avenue
Cypress, CA 90630

Jorge Bowenforbés 61
P.O. Box 1821
Oakland, CA 94621

Betty Braig 131
5271 S. Desert Willow
Gold Canyon, AZ 85019

Joan Breaux 58
830 Kathy Street
Gretna, LA 70056

Gerald F. Brommer 116
11252 Valley Spring Lane
Studio City, CA 91602

Richard Brzozowski 78
13 Fox Road
Plainville, CT 06062

Barbara Burwen 26
12 Holmes Road
Lexington, MA 02420

Karen Brussat Butler 70
169 W. Norwalk Road
Norwalk, CT 06850

Barbara George Cain 12
11617 Blue Creek Drive
Aledo, TX 76008

Pat Cairns 22
4895 El Verano
Atascadero, CA 93422

Sven Ohrvel Carlson 111
43 Broadway
Rockport, MA 01966

Celia Clark 11, 74
RD #2, Box 228A
Delhi, NY 13753

Kathleen Conover 33
2905 Lake Shore Boulevard
Marquette, MI 49855

Ratindra K. Das 107
1938 Berkshire Place
Wheaton, IL 60187

D. Denghausen 23
P.O. Box 11844
Costa Mesa, CA 92627

Marilynn Derwenskus 109
3716 Lakeside
Muncie, IN 47304

D. Gloria Devereaux 17
49 Lester Avenue
Freeport, NY 11520

Joseph DiBella 60
205 Breezewood Drive
Fredericksburg, VA 22407

Robert DiMarzo 54
7124 Hartwell
Dearborn, MI 48126

Liz Donovan 52
4035 Roxmill Court
Glenwood, MD 21738

Cynthia Eastman-Roan 46
4355 Redwood Drive
Oakley, CA 94561

Harriet Elson 19
10 N. Main Street
Munroe Falls, OH 44262

Reneé Emanuel 110
RR6, Box 6427
Moscow, PA 18444

Mary Lou Ferbert 51
334 Parklawn Drive
Cleveland, OH 44116

Pat Fortunato 29
70 Southwick Drive
Orchard Park, NY 14127

Gerald Fritzler 44
P.O. Box 253
Mesa, CO 81643

Dee Gaylord 105
9164 Pioneers Court
Lincoln, NE 68520

Ellna Goodrum 84
7214 Lane Park Drive
Dallas, TX 75225

Harold Gregor 20
107 W. Market Street
Bloomington, IL 61701

Mary Griffin 72
1002 Oakwood Street
Holden, MA 01520

Helen Gwinn 96
608 W. Riverside
Carlsbad, NM 88220

Lori E. Hayes 86
31 Bradford Road
South Hamilton, MA 01982

Phyllis Hellier 83
2465 Pinellas Drive
Punta Gorda, FL 33983

Judy Hoiness 62
1840 NW Vicksburg Avenue
Bend, OR 97701

Winston Hough 133
937 Echo Lane
Glenview, IL 60025

Sandra Humphries 49
3503 Berkeley Place N.E.
Albuquerque, NM 87106

Bill James 8
15840 S.W. 79th Court
Miami, FL 33157

G. Bruce Johnson 88
953 East 173rd Street
South Holland, IL 60437

Howard Kaye 76
Route 8, Box 1
Lincoln, NE 68526

Jay Kelly 40
4-74 48th Avenue, #18E
Long Island City, NY 11109

George W. Kleopfer Jr. 21
2110 Briarwood Boulevard
Arlington, TX 76013

Ann Kromer 56
40 Beechwood Lane
Ridgefield, CT 06877

Frederick Kubitz 123
12 Kenilworth Circle
Wellesley, MA 02482

Andrew R. Kusmin 114
Box 4036, 20 Boston Road
Westford, MA 01886

Donald K. Lake 89
1213 W. William
Champaign, IL 61821

Hal Lambert 75
32071 Pacific Coast Highway
Laguna Beach, CA 92651

Misha Lenn 35
1638 Commonwealth Avenue
Suite 24
Boston, MA 02135

Douglas Lew 101
4382 Browndale Avenue
Edina, MN 55424

Jerry Little 82
2549 Pine Knoll Drive
Walnut Creek, CA 94595

Mary C. Lizotte 9
P.O. Box 93
Norwell, MA 02061

Lynn Leon Loscutoff 68
166 Jenkins Road
Andover, MA 01810

Mary Britten Lynch 129
1505 Woodnymph Trail
Lookout Mountain, GA 30750

Edith Marshall 94
Route 1, Box 57 B
Hancock, MI 49930

Benjamin Mau 30
One Lateer Drive
Normal, IL 61761

Marge McClure 119
840 Tiger Tail Road
Vista, CA 92084

Alex McKibbin 118
3726 Pamajera Drive
Oxford, OH 45056

Patrick D. Milbourn 65
327 West 22nd Street
New York, NY 10011

Dean Mitchell 28
11918 England
Overland Park, KS 66213

Elise Morenon 132
420 Fairview Avenue, Apt. 3C
Fort Lee, NJ 07024

Helen Needles 108
5539 Stokeswood Court
Cincinnati, OH 45238

John A. Neff 63
17 Parkview Road
Wallingford, CT 06492

Ellen Negley 80
824 Forest Hill Boulevard
W. Palm Beach, FL 33405

Lael Nelson 42
600 Lake Shore Drive
Scroggins, TX 75480

Thomas Nicholas 122
7 Wildon Heights
Rockport, MA 01966

Diane J. O'Brien 134
17135 Beverly Drive
Eden Prairie, MN 55347

Carla O'Connor 31
3619 47th Street Court N.W.
Gig Harbor, WA 98335

John O'Connor 93
3231-C Via Carrizo
Laguna Hills, CA 92653

Belle Osipow 66
3465 Wonderview Drive
Los Angeles, CA 90068

Dana-Sue Palemone 104
10635 Sunshine Hill Road
Sonora, CA 95370

Gloria Paterson 135
9090 Barnstaple Lane
Jacksonville, FL 32257

Donald J. Phillips 19
1755 49th Avenue
Capitola, CA 95010

Elizabeth Pratt 41
Box 238 (Mill Road)
Eastham, MA 02642

Judithe Randall 50
2170 Hollyridge Drive
Los Angeles, CA 90068

Judith S. Rein 67
0064 W. Greenlawn Drive
La Porte, IN 46350

Patricia Reynolds 124
390 Point Road
Willsboro, NY 12996

Edna Rideout 95
18616 92nd Avenue N.E.
Bothell, WA 98011

Jerry Rose 14
700 Southwest 31st Street
Palm City, FL 34990

Jeanne A. Ruchti 13
4639 Meadowlark Street
Cottage Grove, WI 53527

Joan Rudman 59
274 Quarry Road
Stamford, CT 06903

Robert Sakson 85
10 Stacey Avenue
Trenton, NJ 08618-3421

John Salchak 121
18220 S. Hoffman Avenue
Cerritos, CA 90703

Hannelore Sangmaster 115
1052 Woodridge Road
Placerville, CA 95667

Charlu Schilling 106
309 Sterling Avenue
New Castle, DE 19720

Suzy Schultz 87
D. Miles Gallery
120 Sycamore Place
Decatur, GA 30030

Barbara Scullin 16
128 Paulison Avenue
Ridgefield Park, NJ 07660

George Shedd 15
46 Paulson Drive
Burlington, MA 01803

Marie Shell 34
724 Nature's Hammock Road W.
Jacksonville, FL 32259

Donna Shuford 100
716 Water Oak Drive
Plano, TX 75025

Edwin C. Shuttleworth 27
3216 Chapel Hill Boulevard
Boynton Beach, FL 33435

Ruth Sklar 45
14569 Benefit Street, #106
Sherman Oaks, CA 91403

Wayne Skyler 24
20 Hickory Drive
Stanhope, NJ 07874

Electra Stamelos 120
38131 Vista Drive N.
Livonia, MI 48152

Colleen Newport Stevens 25
8386 Meadow Run Cove
Germantown, TN 38138

Penny Stewart 90
6860 Cedar Ridge Court
Colorado Springs, CO 80919

Charles I. Stratmann 69
5084 Atlantic View
St. Augustine, FL 32084

Shirley Zampelli Sturtz-Davis 125
265 Newville Road
Shippensburg, PA 17257

Carl Sublett 43
2104 Lake Avenue
Knoxville, TN 37916

Marilyn Swift 112
20 Highland Street
Gloucester, MA 01930

Bill Teitsworth 64
RR6, Box 6427
Moscow, PA 18444

ABOUT THE JUDGE

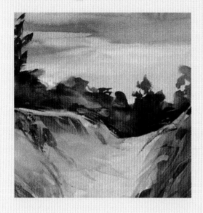

BETTY LOU SCHLEMM, A.W.S., D.F., *has been painting for more than forty years.*

Elected to the American Watercolor Society in 1964 and later elected to the Dolphin

Fellowship, she has served as both regional vice president and director of the American

Watercolor Society. Ms. Schlemm is also a teacher and an author. She has conducted

renowned painting workshops in Rockport, Massachusetts, for the past thirty years. Her book

Painting with Light, *published by Watson-Guptill in 1978, has become a classic. She recently*

published Watercolor Secrets for Painting Light, *distributed by North Light Books-F & W*

Publications, Cincinnati, Ohio.

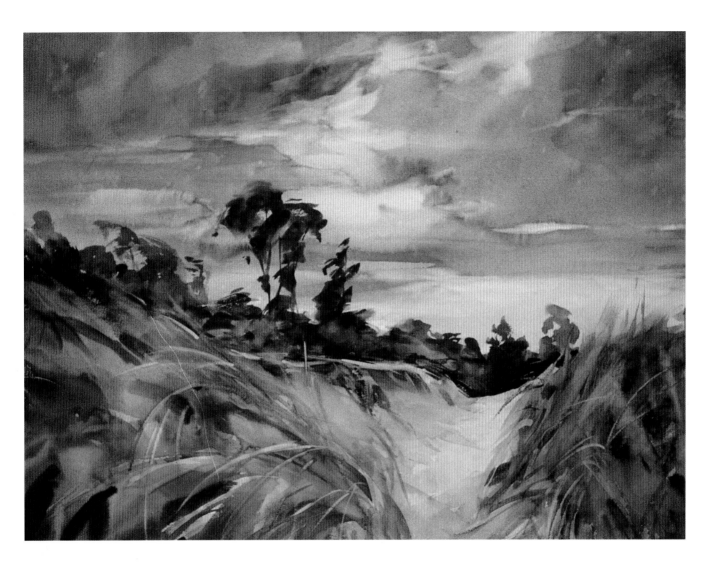

Betty Lou Schlemm
Sandy Beach

22"X40"